MASTERPIECES OF PAINTING

MASTERPIECES OF PAINTING IN THE METROPOLITAN MUSEUM OF ART

INTRODUCTION BY CLAUS VIRCH

COMMENTS ON THE PAINTINGS BY

EDITH A. STANDEN & THOMAS M. FOLDS

THE METROPOLITAN MUSEUM OF ART

DISTRIBUTED BY NEW YORK GRAPHIC SOCIETY LTD.

PHOTOGRAPHS 2, 5, 6, 8, 9, 12, 25, 31, 32, 39, 45, 54, 58, 65, 78, 89, 90, 92, 96
BY WILLIAM F. PONS; ALL THE REST BY MALCOLM VARON

DESIGNED BY PETER OLDENBURG · PRINTED IN WEST GERMANY BY BRÜDER HARTMANN, BERLIN
ALL RIGHTS RESERVED
LIBRARY OF CONGRESS CATALOG CARD NUMBER 78-123876
STANDARD BOOK NUMBER: CLOTH BINDING 87099-015-2, PAPERBOUND 87099-016-0

CONTENTS

16642

INTRODUCTION

One hundred years ago it would have been impossible to choose a hundred masterworks of painting from the Metropolitan Museum's collection. Masterpieces were then hanging in the great museums of Europe—in the Louvre, the National Gallery in London, the Alte Pinakothek in Munich, the Uffizi in Florence—but here in the Metropolitan there were no masterpieces. In fact there were no paintings at all. The group of men who founded the Museum in 1870, with little more tangible than vision and good will, were optimistic, but not in their wildest hopes could they have foreseen the spectacular success story that followed. The Museum's riches in all fields of art are now justly termed encyclopedic, but it could be called a great museum today for its paintings alone.

The Department of European Paintings is the oldest of our numerous departments. The Museum barely existed, having been incorporated on April 13, 1870, when, during that summer, one of its Trustees bought three European collections consisting of 174 paintings. "In possessing them," Henry James wrote later, in a mildly critical review, "the Metropolitan Museum of Art has an enviably solid foundation for future acquisition and development." Though I do not hold a high opinion of James as an art critic, here he was certainly right. Considered rash at the time, the first purchase, totaling $116,180, turned out to be a sound investment. Quite a number of the original 174 have since, through scholarly reconsideration or changes of taste, found their way to the cel-

lar, but several still rank among the Museum's best, and one alone, reproduced on page 32 of this book, would command a higher price today than the whole lot did a century ago.

It was Benjamin Altman's bequest of truly great works of art in 1913 that really established the importance of the collection. The list of bequests and gifts that rapidly followed is long and glorious. The names of the public-spirited collectors who wished to share these private treasures of theirs with the Museum's growing number of visitors are inseparably associated with the works of art they gave. Some of these names will be encountered in the following pages: Marquand, Morgan, Catharine Lorillard Wolfe, the Havemeyers, Friedsam, Bache, Blumenthal. Nor should we forget the donors of funds that enabled us to buy occasionally an important work to round out the comprehensive representation or add a special star. However, it is worth noting that *Aristotle Contemplating the Bust of Homer*, acquired in 1961, was the first of the Museum's many works by Rembrandt to be bought. Likewise, *Terrace at Sainte-Adresse*, acquired in 1967, is the only work by Monet purchased. This striking early canvas joined the more than thirty Monets in our collection to represent still another phase of this most important landscape painter. Other judicious purchases have brought key works to the Museum, a point demonstrated by the relatively large number reproduced in this book that have been bought.

Choosing masterpieces can be fun and

games as long as it remains wishful thinking. The Museum's late Director, James J. Rorimer, enjoyed asking me such questions as "Would you rather have for the Museum the Frick's *Ecstasy of St. Francis* by Bellini or Isabella Stewart Gardner's *Rape of Europa* by Titian?" or "Which is the greater work of art, *The Burial of the Count of Orgaz* by El Greco in Toledo or *Las Meninas* by Velázquez in the Prado?" Such questions would lead to interesting discussions, but from the curatorial point of view any answer was fruitless, since in all probability the mentioned paintings could neither be bought nor borrowed.

Choosing the hundred paintings for this book, however, posed entirely real problems. Since the book is beginning its career as the catalogue of a loan exhibition to the Boston Museum of Fine Arts in celebration of its hundredth anniversary, certain works could not be included because they cannot travel. The three tremendous canvases belonging to the series with which the young Giovanni Battista Tiepolo decorated the Ca' Dolfin in Venice about 1732 would rank high on my, or anyone's, list, but they are too fragile to be rolled up, which their size would necessitate for transportation. The paintings in the Altman Collection cannot be moved from the Museum under the terms of the bequest, obliging us to omit, for example, such haunting portraits by Rembrandt as *Lady with a Pink* and *Man with a Magnifying Glass,* Francia's *Federigo Gonzaga,* an enchanting evocation of delicate childhood and early sorrow, and Ruisdael's *Wheatfields,* one of the greatest landscapes ever painted. What to select in the areas where the Museum's holdings are particularly strong? The popular paintings of the impressionists, so well represented in the Museum, could easily upset the balance of all schools and periods, which this book—as well as the Museum—seeks to uphold. Should all our paintings by El Greco, each

outstanding in its own right, be included, or should other Spaniards be given their chance? The final list, even if some of the choices appear arbitrary, is certainly distinguished. With such material available, it would indeed be difficult to fail.

The selection of paintings by American artists was made by John K. Howat, Curator of the Department of American Paintings and Sculpture, and that of the contemporary works—five key paintings of the modern American school—by Henry Geldzahler, Curator of the Department of Twentieth Century Art. Let us note that the Museum's collection of American paintings started out as a more or less contemporary one. In 1873 the Trustees "passed the hat" among themselves (as they would continue to do long after purchase funds had been established), and the first painting by an American, *The Wages of War* by Henry Peters Gray (1819–1877), was acquired as the "gift of several gentlemen." In the same year the Museum received as a gift the body of works painted during his last summer by John F. Kensett, one of the Museum's founders, who had died the year before. Eventually, the young institution was to own some of the best and some of the most famous pictures painted by Americans, and today it can offer one of the most comprehensive surveys of American paintings anywhere. But in this book the limitation of space has made the selection for my "American" colleagues considerably more painful—or simple—than for me.

Since this is essentially a picture book, the remarks beneath the reproductions are brief and to the point. My colleagues and I warmly acknowledge the contribution of Edith A. Standen, Associate Curator of Textiles, who comments on the European paintings, and Thomas M. Folds, Dean of Education, who comments on the American. Readers who seek fuller information on these works will find most of them treated in one or another of the scholarly catalogues that

the Museum continues to publish as part of its endeavor to render the collections more accessible and instructive. Particularly recommended are Volumes II and III of our Catalogue of French Paintings, Volume I of our Catalogue of American Paintings, and our book *American Painting in the Twentieth Century*. The first volume of our four-volume publication of the Museum's Italian paintings is to appear shortly.

In the present book, the pictures themselves are meant to speak, to tell us of men and women of the far and recent past: of what they wore and what they worshiped, of their amusements, of their deepest concerns. This certainly is the magic power of a masterpiece, that it can tell us so much about a country, a period, a person—and eventually ask us about ourselves, a question that, after all, is man's most complex and enduring preoccupation.

A great work of art needs contemplation. The longer we look at it, the more we study and "read" it, the more meaning we will gain. Recent decades have taught us the quick image. It flashes by and we quickly grasp it. We are inundated by illustrations, photographs, advertisements, television, and books of color reproductions similar to this one. Images attack us like sound, which nowadays is ever present around us, be it music or simply noise. How different the world was only a hundred years ago. Photography was in its infancy, and color photography did not exist at all. Words reigned supreme and the most popular practitioners of the arts were writers. Their novels were read, their poems recited. Today, names of painters are better known than those of writers. To people who may never have heard of Milton or Proust, Rembrandt and Picasso have become household words. Our bookstores are full of picture books. People want to look, not read, and for many of us a blurry photograph in a newspaper tells its story more effectively than an article. There

should be no surprise in this. It was Cicero who called sight the keenest of all our senses.

Reproductions, especially color reproductions, have done a great deal to stimulate an almost worldwide interest in art. They have brought art to millions who would have no access to an original work. And this much is good. But let there be a warning: a color reproduction, however well executed, can never replace the experience of the original work of art. Consider the following pages. Every care has been taken to render an honest account, and yet, first of all, pictures of vastly varying sizes are reduced to fit on these pages. Next, pictures varying greatly in painting technique are made similar by the printing process. The personality of a masterwork—the individuality that makes it a masterwork—has thus been largely suppressed.

Keep in mind another point. In a way, this book continues a development that was initiated when museums alienated works of art from their surroundings and removed relevance to such an extent that pictures became "abstract." Giotto's *Epiphany* and Lorenzo Monaco's *Noah* and *Abraham*, for example, were once parts of large altarpieces, dismembered long ago; Sassetta's *Journey of the Magi* is the upper part of an Adoration sawed into two; Van Eyck's *Crucifixion* and *Last Judgment* were the wings for a lost central painting; Bruegel's *Harvesters* is only one of a series representing the months or the seasons. Ribera's *Holy Family* was meant to be worshiped on the altar of a Spanish chapel, while Boucher's *Toilet of Venus* was painted to decorate Mme. de Pompadour's bathroom at the Château de Bellevue. Pictures painted for definite purposes, definite places, definite people. It is difficult for us now to recall their ambience, just as it is rare today to find paintings in their original surroundings. It was only in the nineteenth century that

9

pictures began to be painted for unknown clients and unknown walls, for exhibition at the Salon and the reviews of critics. This was also the century that saw the building of museums, where these paintings, refugees from châteaux and chapels, could be seen as equals with more recent works, in long rows of uniformly skylighted galleries, like specimens preserved under glass. On this road of abstracting, the book of color plates goes one step further. It removes the frames, sometimes the original one, more often a later, arbitrary addition, but usually a necessity for "holding the picture together," thus stripping the works of their last bit of "surroundings." Modern pictures, which are often conceived without frames or specific surroundings, fare better in the process of color reproduction, a fact that has induced many modern painters to make their own reproductions of their works in lithographs, silkscreens, or by other means.

Yet some of these things may be minor considerations if a book like ours fulfills its function, which is to prepare the "reader" for his confrontation with the original, or to guide and refresh his memory of it. Whether appetizer or souvenir, the book relies on the encounter with the actual work. However, a passage in Jonathan Swift's *Tale of a Tub* is pertinent: "I have always looked upon it as a high point of indiscretion in monster-mongers, and other retailers of strange sights, to hang out a fair large picture over the door, drawn after the life, with a most eloquent description underneath. This hath saved me many a three-pence; for my curiosity was fully satisfied, and I never offered to go in, though often invited by the urging and attending orator." Our "fair pictures" with their "eloquent descriptions" will fare better, we hope, and rouse rather than satisfy curiosity. Meanwhile, this book stands by itself as a proud record of a hundred great paintings in the Metropolitan Museum, containing, as in a capsule, nearly seven hundred years of visual history.

CLAUS VIRCH
Curator, Department of European Paintings

ITALIAN SCHOOL

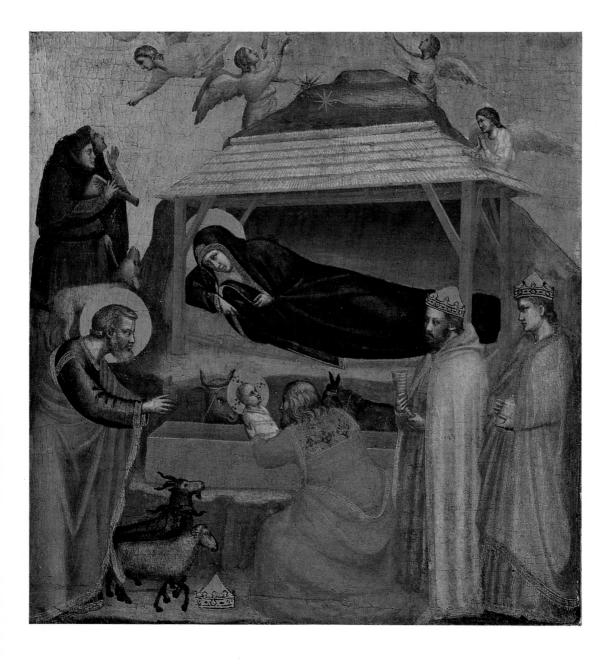

GIOTTO DI BONDONE (?)

Florentine, 1266/67–1333

The Epiphany

Tempera on wood, gold ground, 17¾ × 17¼ in.
John Stewart Kennedy Fund, 11.126.1

This little picture is one of a set of seven or more telling the story of
Christ. Giotto has combined two episodes—the angelic message given
to the shepherds and the presentation of gifts by the three kings to
the Child wrapped in swaddling clothes. Two shepherds, one with a
bagpipe, and their dog listen to the angels, while some of their flock
have come ahead of them to the stable. Joseph holds the covered cup
presented by the first king, who has taken the Child into his arms, an
unusual gesture. Though the background is still the flat gold of Byzan-
tine paintings, the figures are substantial and three-dimensional. All
have the solemn bearing of people engaged in one of the most impor-
tant acts of their lives.

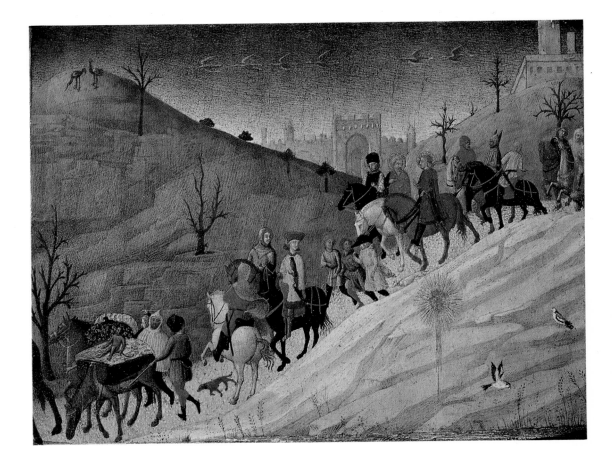

SASSETTA (STEFANO DI GIOVANNI)

Sienese, 1392–1450

The Journey of the Magi

Tempera on wood, 8½ × 11⅝ in.
Bequest of Maitland F. Griggs, 43.98.1

This panel, though accidentally a satisfactory composition, is clearly a fragment. The position of the great golden star, not in the sky to be followed, but at rest over the missing stable below, shows that this is the upper part of an Adoration of the Magi; the lower portion is in the Chigi-Saraceni Collection in Siena. Though it is regrettable that the picture was cut, the consequent focusing of attention on a minor scene has had some fortunate results. The pink city walls, the monkey—comfortably traveling on horseback—the dogs, the birds, and above all the spirit of joy apparent in the procession have been loved by many people who might not have noticed them if the picture had remained intact.

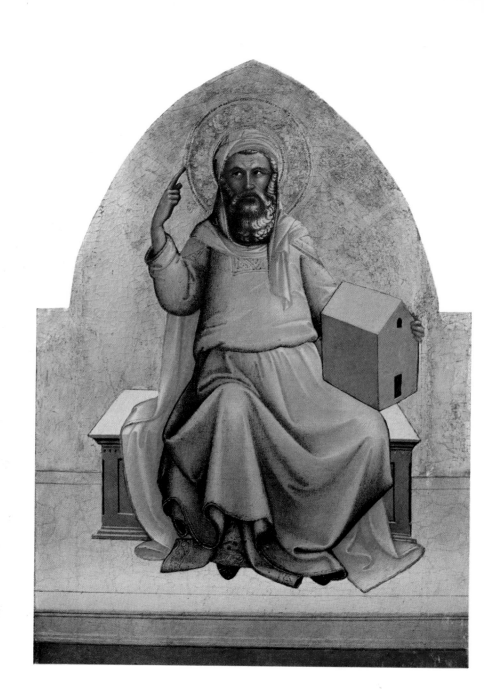

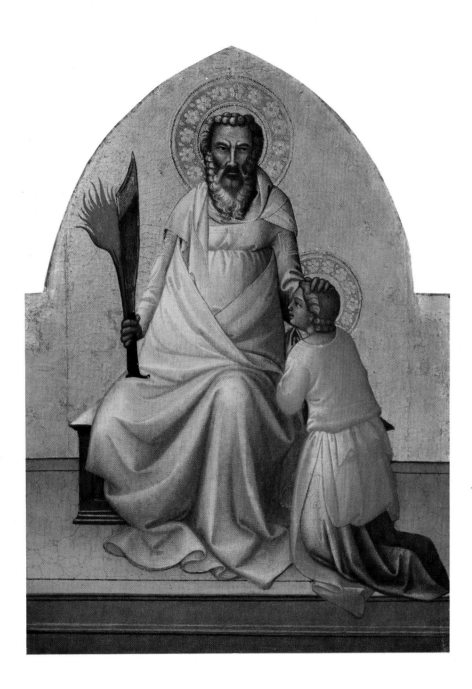

LORENZO MONACO
(PIERO DI GIOVANNI)

Florentine, about 1370–1425

Noah and *Abraham*

Tempera on wood, gold ground,
 Noah, 23 × 17 in., *Abraham*, 23 × 16⅝ in.
Gwynne Andrews Fund, Marquand Fund,
 and gifts of various donors, 65.14.1,2

These are two of four related panels in the Metropolitan Museum by the painter known as Lorenzo the Monk. In them, Old Testament figures are shown as prefigurations of the New Dispensation, certainly the main subject of the altarpiece to which the panels belonged. Noah holds a totally unseaworthy, purely symbolic Ark; it is not a ship but a house, that is, the House of God. The Ark saved man from the Flood; the House of God—the Church—saves him from destruction by sin. The sacrifice of Isaac, for which Abraham carries fire and a knife even as he blesses his son, foreshadows the sacrifice of Christ. Lorenzo Monaco's combination of Gothic linearism with Giottoesque plasticity makes these figures both decorative and imposing.

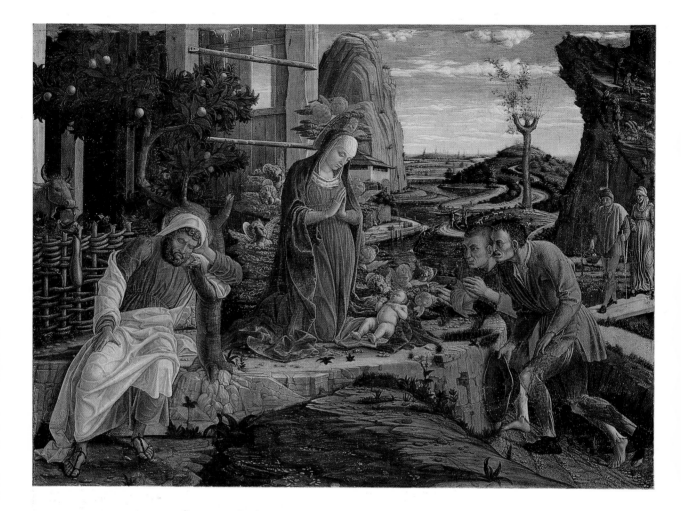

ANDREA MANTEGNA

Paduan, 1431–1506

The Adoration of the Shepherds

Tempera on canvas, transferred from wood,
 15³/₄ × 21⁷/₈ in.
Anonymous gift, 32.130.2

It is very early in the morning. In the distance, standing on fearsome crags or level river meadows, angels have come to earth to give the good tidings to isolated shepherds. The men and women who received the message during the night have arrived at their journey's end; their clothes are torn and patched, their homely faces distorted by the intensity of their feelings. A host of celestial beings, all red and gold in blue clouds, surrounds the Child and his Mother; behind them an immense landscape stretches to an infinitely distant horizon. Over everything, natural and supernatural—the plain people, the Holy Family, the cherubim, the planks of the stable, the river bank—the cool, revealing light falls gently and unobtrusively from low in the eastern sky.

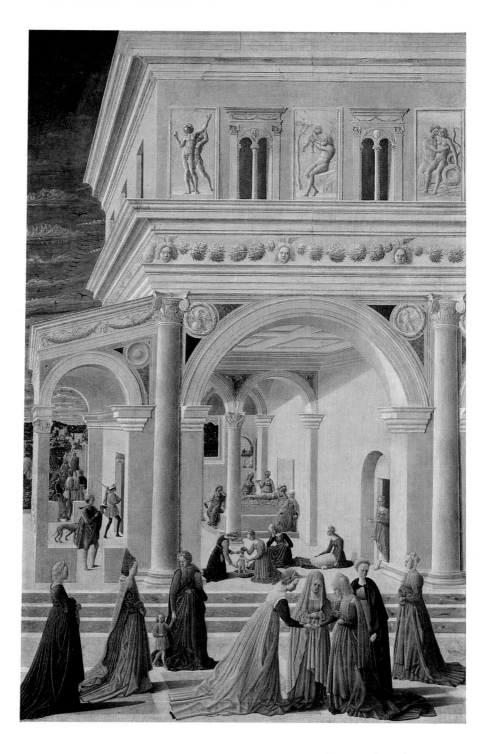

MASTER OF THE BARBERINI PANELS
(GIOVANNI ANGELO DI ANTONIO?)

School of the Marches, active about
 1447–1475

The Birth of the Virgin

Tempera and oil on wood, 57 × 37⅞ in.
Rogers and Gwynne Andrews Funds, 35.121

This panel and its companion piece in the Museum of Fine Arts, Boston, are two of the most enigmatic Italian paintings in existence; their very subjects are uncertain and their authorship much disputed. They came from Urbino and were later in the Barberini Palace in Rome. They date from the 1470s. Giovanni Angelo di Antonio is known only from documents, but the facts of his life are consistent with the various influences that can be traced in these works. Though the painter had certainly studied several of his great contemporaries, such as Piero della Francesca, his originality is unmistakable. The variety and subtlety of the colors, the masterly handling of the complicated spaces, the quiet dignity and beauty of the slow-moving figures, combine to form visions of a world better ordered than the one we inhabit.

VITTORE CARPACCIO

Venetian, about 1455–1523/26

The Meditation on the Passion

Tempera on wood, 27³/4 × 34¹/8 in.
Signed (lower right): vjctorjs carpattjj/venetj
 opus (the work of Vittore Carpaccio of
 Venice)
John Stewart Kennedy Fund, 11.118

Some religious paintings show biblical scenes as actual events; others offer subjects for meditation and are meant to stimulate far-reaching trains of pious thought. Such works can be simple, but often they are very complicated, with every detail having a symbolic meaning. Here the body of Christ rests on a broken throne with distorted Hebrew letters, which, like the grim mountains on the left, represents the Old Law. Job is on the right; the Hebrew inscription on the stone beneath him includes his words, "I know that my redeemer liveth." St. Jerome, who wrote a commentary on the Book of Job, sits on the left side with his identifying lion nearby. The fertile landscape on the right is a symbol of man's salvation, won by the passion of Christ.

GIOVANNI GIROLAMO SAVOLDO

Brescian, active from 1508, d. soon after 1548

St. Matthew and the Angel

Oil on canvas, 36³/₄×49 in.
Marquand Fund, 12.14

St. Matthew is said to have brought Christianity to the kingdom of
Ethiopia. The queen's eunuch befriended him, and the scene in the
background of this picture, at the right, shows the eunuch and the
saint by a blazing hearth. Matthew converted the queen, but could
not approve the king's wish to marry an abbess who was his own
niece. In the upper left corner the saint is being martyred at the king's
command in front of a strange-looking church by moonlight. The fire
on the right, the moon on the left, cast their distinctive lights, but it
is the oil lamp in the foreground that illuminates the red and purple
draperies of the Evangelist, as he pauses in writing his Gospel, and
those of his symbol, an angel.

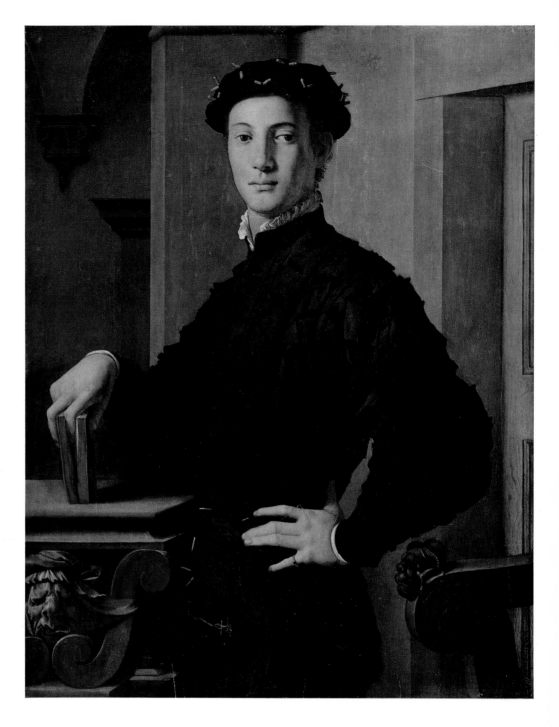

BRONZINO
(AGNOLO DI COSIMO DI MARIANO)

Florentine, 1503–1572

Portrait of a Young Man

Oil on wood, 37⅝ × 29½ in.
The H.O. Havemeyer Collection
Bequest of Mrs. H.O. Havemeyer, 29.100.16

The youthful aristocrat wears the solid black costume usual in mid-sixteenth-century Italy, relieved only by white linen at the neck and wrists, a gold ring, and glittering gold tags, clustered most thickly on his cap. His bearing is one of cool, easy superiority, too calm and confident to be called self-satisfaction or arrogance. He dominates without effort an uneasy background of unexplained ins and outs of walls, half-seen doors, and architectural details. The extraordinary colors of the table and chairs, with their fantastically distorted, grotesque carved heads, serve to emphasize the sitter's regular, icy beauty and his immobility, his remoteness from the vulgar world of emotion and ugliness. This is Bronzino's version of the mannerist conception of portraiture.

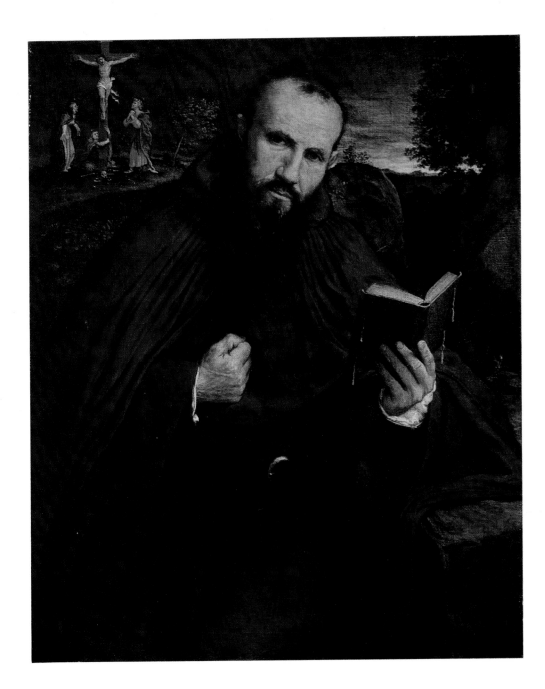

LORENZO LOTTO

Venetian, 1480–1556

Brother Gregorio Belo of Vincenza
(b. 1492)

Oil on canvas, 34³/₈ × 28 in.
Inscribed (on stone, lower right) with sitter's
 name and age (55) and dated 1547
Rogers Fund, 65.117

Brother Gregorio holds his book and smites his breast as he looks intensely at the spectator. The only bright colors are those of the tiny Crucifixion in the upper left corner. It is as if the monk were saying, "This is my chief concern; it should be yours." The wild and gloomy background is a landscape of the mind, not the normal, physical surroundings of the sitter, as in the portraits by Moroni (page 22) and Bronzino (page 20). These three works were painted within the same twenty-five years; they show a lawyer, an aristocrat, and a monk. Together they tell us a great deal about the styles of the different artists, but perhaps even more about the variety of human beings.

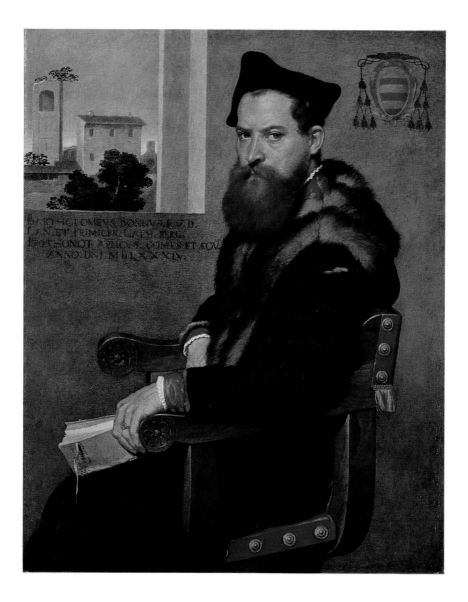

GIOVANNI BATTISTA MORONI

Brescian, 1525–1578

Bartolommeo Bongo (d. 1584)

Oil on canvas, 40 × 32¼ in.
Joseph Pulitzer Fund, 13.177

The subject of this realistic portrait was a distinguished cleric and lawyer of Bergamo. His coat of arms, surmounted by an ecclesiastical hat, appears on the wall, and the twelfth-century Torre del Comune of Bergamo is seen through the window. Its ruinous state is not symbolic; the Palazzo del Ragione, or town hall, of which it is a part, had only just been restored after a fire, and the tower was not to be finished for another hundred years. The book the sitter holds has a legible title; it is an edition of Justinian dedicated to Bongo in 1553, the probable date of the portrait. The Latin inscription under the window and the date 1584 were added after both artist and sitter had died.

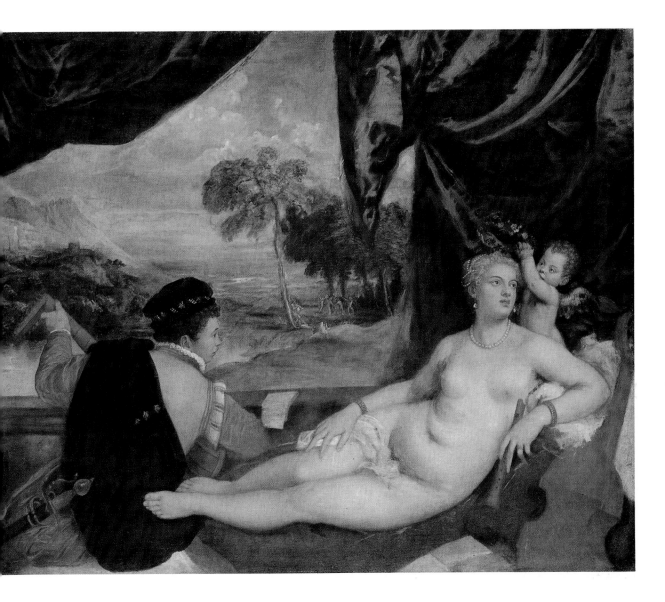

TITIAN (TIZIANO VECELLI)

Venetian, 1477–1576

Venus and the Lute Player

Oil on canvas, 65 × 82½ in.
Munsey Fund, 36.29

The subject was one of Titian's favorites. This version was painted when the artist was in his eighties, if the date he gave for his birth is correct. The sharply outlined forms of the young man's cape and cap and the abrupt angle at which he turns impetuously toward the object of his adoration are contrasted with the languorous curve of Venus's smooth, pearly body. Between the great swags of drapery is a landscape background where contours disappear, and we see only form and color; a few brushstrokes are enough to create a distant bagpiper playing to a ring of naked dancers. Even more striking than the variety of techniques and the mastery of composition is the intensity of sensuous feeling; the air is heavy with music and love.

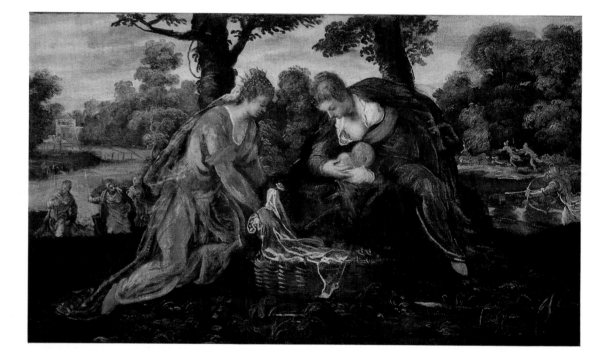

TINTORETTO (JACOPO ROBUSTI)

Venetian, 1518–1594

The Finding of Moses

Oil on canvas, 30¹/₂ × 52³/₄ in.
Gwynne Andrews Fund, 39.55

The sketchy, brilliant style of this picture is as typical of Tintoretto as it is attractive to modern taste. The splashy reds and yellows of the robe worn by Pharaoh's daughter might, to contemporaries, have seemed too glaring and in need of finishing glazes, but we can be glad that the artist did not tone them down. The small figures in the background, especially those in the hunting scene on the right, are particularly characteristic. The deer and the dog are scarcely solid bodies at all, but almost pure movement; the archer is a swirl of action, as if painted with light. The twisted pose of the servingwoman holding the baby demonstrates Tintoretto's artistic delight in displaying the human form in complicated postures.

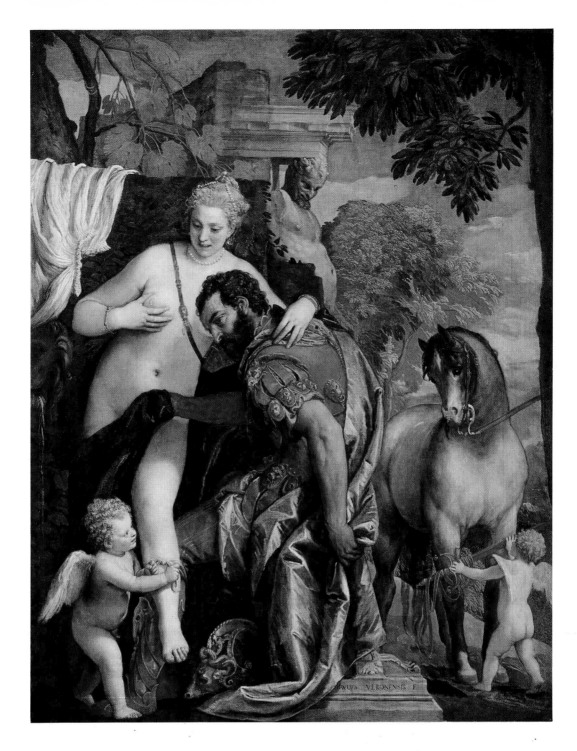

VERONESE (PAOLO CALIARI)

Venetian, 1528(?)–1588

Mars and Venus United by Love

Oil on canvas, 81 × 63³/₈ in.
Signed (on pedestal, lower center):
 PAVLVS VERONENSIS. F. (Paul of Verona
 made it)
John Stewart Kennedy Fund, 10.189

The title and meaning of this picture are uncertain. It may commemorate a marriage and show Chastity transformed by Love into Charity; the horse certainly is a symbol of base passion, here kept in restraint by the cupid with a golden sword. The supportive figure in the background, with his sly leer, seems to question the efficacy of the gesture, but he is merely a statue. The color scheme is characteristic of Veronese. He loved to place bright things on dark grounds, like Venus's fair hair and white shift against the wall, or the yellow leaf against the deep blue sky in the upper left corner; this gives an uncanny, magical impression, since we commonly see things dark against a light sky.

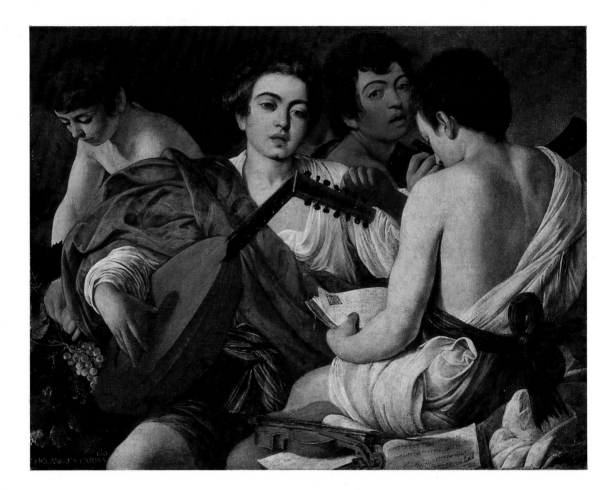

MICHELANGELO DA CARAVAGGIO

Roman, 1573–1610

The Musicians

Oil on canvas, 36¼ × 46⅝ in.
The signature (lower left) is a later addition
Rogers Fund, 52.81

As a young, brash newcomer in Rome, Caravaggio found it hard to make a living. He proclaimed revolutionary ideas, such as painting directly from life without preparatory drawings, and he did not imitate the long-admired artists, such as Raphael, who were venerated as "old masters." Fortunately, he found a sympathetic patron, Cardinal del Monte, for whom he painted this *musica,* as it was called, about 1594. It has no meaning or purpose, except to portray clearly lit youthful forms in a tangle of shapely limbs and complicated draperies. Against these, the sharp edges and angles of the lute stand out like a kind of counterpoint. The still life of grapes and vine leaves on the left also shows the artist's pleasure in bright light falling on various surfaces.

SALVATOR ROSA

Neapolitan, 1615–1673

The Dream of Aeneas

Oil on canvas, 77$^{1}/_{2}$ × 47$^{1}/_{2}$ in.
Rogers Fund, 65.118

"It was night... Aeneas, perplexed in mind by this untoward war, lay down, and suffered sleep to spread, though late, through all his limbs. To him father Tiberinus, god of the place, seemed to rise from the delightful stream among the poplar leaves: a linen robe enwrapped his limbs in sea-green folds, and a crown of reeds covered his head." Father Tiber informed Aeneas that he had come to the end of his travels and foretold his successful future. This episode from Virgil, seldom illustrated, was a typical choice for Rosa, a willfully original and independent-minded artist. He is better known for his wild landscapes with banditti than for mythological subjects, but this unusual picture also displays his typically turbulent and romantic spirit.

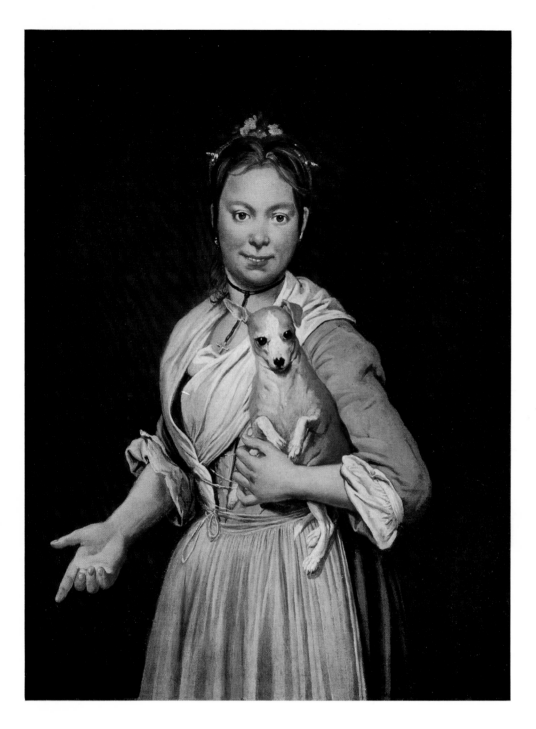

GIACOMO CERUTI

North Italian, fl. 1724–1757

A Woman with a Dog

Oil on canvas, 38 × 28¹/₂ in.
Maria DeWitt Jesup Fund, 30.15

Sometimes a provincial artist, instead of making mere dim reflections of work being done in the great creative centers, strikes out on his own. His local traditions can inspire him and enable him to achieve small triumphs, utterly different from the paintings of his contemporaries. Such an artist was Giacomo Ceruti of Lombardy, who, in the mid-eighteenth century, studied the naturalistic portraits that such artists as Moroni had painted two centuries before. With their help he developed a completely individual style, putting on canvas such vivid and convincing figures as this servant girl holding her mistress's dog. Ceruti has looked at her without laughter, condescension, or sentimentality. She is a person in her own right, reminding us of the lively soubrettes in Mozart's operas.

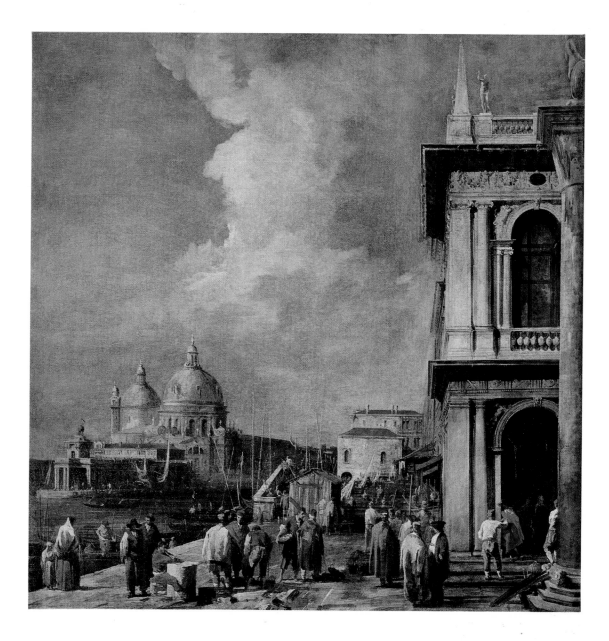

CANALETTO (ANTONIO CANALE)

Venetian, 1697–1768

Scene in Venice: The Piazzetta

Oil on canvas, 51 1/2 × 51 1/4 in.
John Stewart Kennedy Fund, 10.207

If a visitor to Venice today stands at the edge of the Piazzetta and looks across the Grand Canal at Santa Maria della Salute, he sees almost exactly this prospect, including the gondolas, still made in the same shape. The classical building on the right is the Libreria Vecchia, or Old Library. Across the water, to the left of the church, is the Dogana, or Custom House, surmounted by the figure of Fortune standing on her gilded ball and turning with the wind. The visitor will not, however, see some of Canaletto's details, such as the black hens in cages and people in rags. Venice in the 1740s was already a tourist resort, and Canaletto painted her soberly, accurately, and affectionately for contemporary visitors and posterity.

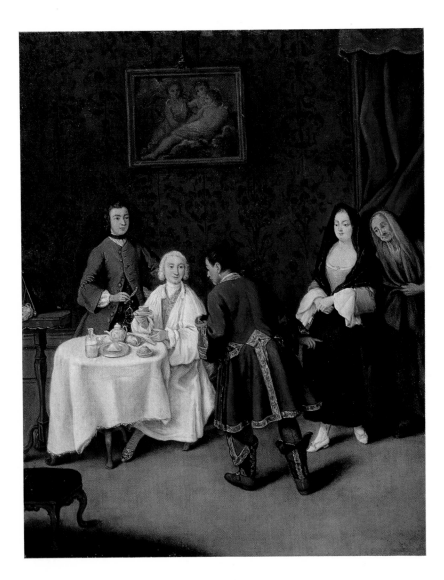

PIETRO LONGHI (PIETRO FALEA)

Venetian, 1702–1785

The Temptation

Oil on canvas, 24 × 19¹/₂ in.
Gift of J. Pierpont Morgan, 17.190.12

Longhi painted a set of twenty-four little scenes of everyday Venetian life for a Florentine purchaser. They do not tell a connected story, but some, like this (which is one of four in the Metropolitan), are anecdotal. A fine young gentleman in a white wig, informally though elegantly dressed, is taking a light meal in his bedroom, his valet beside him. A servant wearing an earring is making an introduction; the woven bands that ornament his livery mark his status. The plump girl escorted by a crone looks self-satisfied; she may be beginning an important career, for Venetian courtesans were famous. Nothing out of the way is happening; no moral is drawn. How differently Hogarth would have painted this scene!

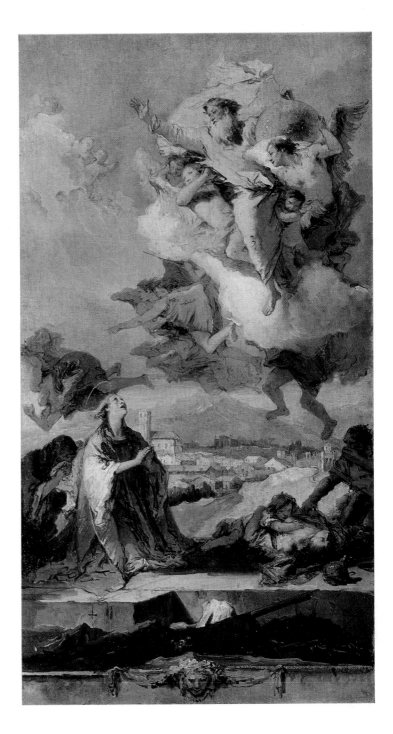

GIOVANNI BATTISTA TIEPOLO

Venetian, 1696–1770

*St. Thecla Praying
for the Plague-stricken*

Oil on canvas, 32 × 17⅝ in.
Rogers Fund, 37.165.2

The little town of Este, near Padua, has a cathedral dedicated to St. Thecla, the friend of St. Paul. When its citizens were afflicted by the plague in 1630, they turned to their patron saint and, thanks to her intercession, its ravages ceased. This was the subject chosen to decorate the apse behind the cathedral's high altar; the huge painting by Tiepolo, finished in 1759, is still in place and is the town's greatest treasure. Its composition is shown in this sketch: the saint kneeling at the left, the ghastly effects of the plague illustrated on the right, and, above, God sweeping down from heaven in answer to her prayer.

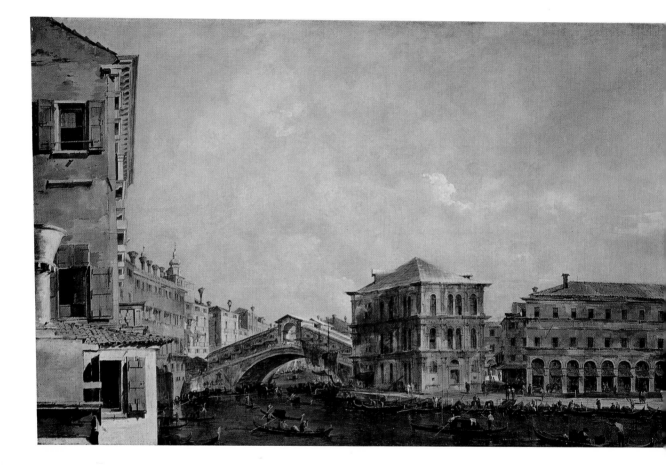

FRANCESCO GUARDI

Venetian, 1712–1793

The Rialto, Venice

Oil on canvas, 21 × 33¾ in.
Purchase, 71.119

Few modern tourists can take home from Venice the valuable souvenirs that some mid-eighteenth-century visitors were able to acquire. Instead of post cards they bought paintings, often by members of the Guardi family. If they were discerning and lucky, these were by Francesco, the most accomplished of the Guardis. An example is this view of the famous bridge, a picture that has been in the Metropolitan nearly a century. The spectator is looking along the Grand Canal, as if coming from the railroad station to Saint Mark's. Across the water is the fruit and vegetable market under the arcade of the Fabbriche Vecchie di Rialto and the great bulk of the sixteenth-century Palazzo Camerlenghi. The clear, watery atmosphere of Venice suffuses the entire picture.

DUTCH, FLEMISH, AND GERMAN SCHOOLS

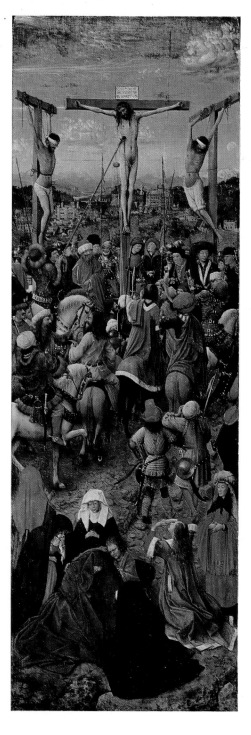 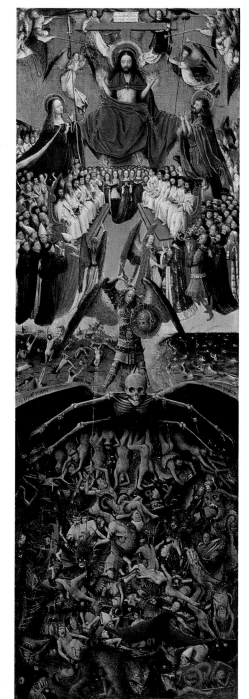

HUBERT VAN EYCK

Flemish, d. 1426

The Crucifixion and
The Last Judgment

Tempera and oil on canvas, transferred from
wood, each 22¼ × 7¾ in.
Fletcher Fund, 33.92 a, b

Hubert van Eyck and his younger brother, Jan, both worked on the great Adoration of the Lamb altarpiece in Ghent. These wings of a small triptych are among the few pictures attributed to Hubert alone. They show the almost incredible precision of detail, sometimes visible only under a magnifying glass, for which both brothers are famous. Everything in these paintings is sharp and clear, every stone or tortured body in the foreground, every building or splitting grave or white-capped wave behind the main figures—even the snowy mountains of one panel and the distant horizon of the other. Despite this minuteness, each painting is splendidly telling as a whole. The colors are brilliant throughout, except in hell; here, even a king's crown has only a dull red glow.

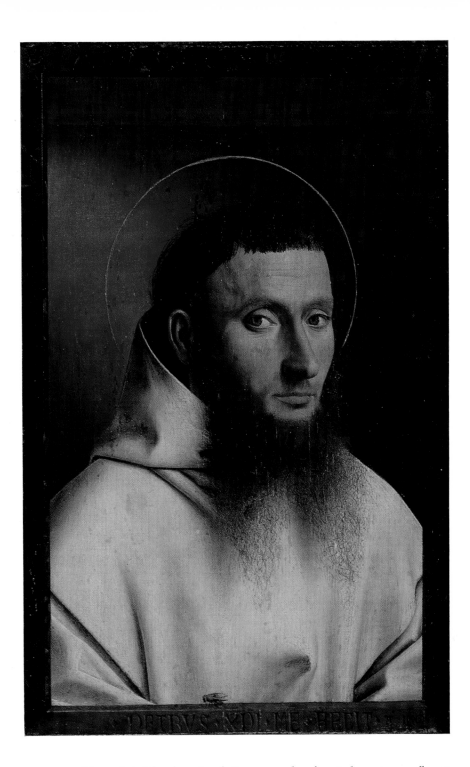

PETRUS CHRISTUS

Flemish, active by 1444, d. 1472/73

Portrait of a Carthusian

Tempera and oil on wood, 11½ × 8 in.
Signed and dated (lower center):
 PETRVS . XPI . ME . FECIT . A° 1446
 (Petrus Christus made me in the year 1446)
The Jules Bache Collection, 49.7.19

The painted border, simulating a wooden frame, has a green fly on the lower edge; this creature could be a symbol of sin, overcome by the saintly monk, or perhaps the painter was simply showing off. His name is painted as if carved on the frame (xpi is an abbreviation of the Greek form of Christus). The red background is unusual. A very real, though perhaps reticent, man looks out at us; he is so individualized that the picture must be a portrait. The fluffy beard is contrasted with the firm shapes of the features and the solid folds of the woolen robe. Wrinkles and veins are sharply delineated, the skull can be sensed behind the forehead, and the eyeballs, nose, and lips are fully three-dimensional.

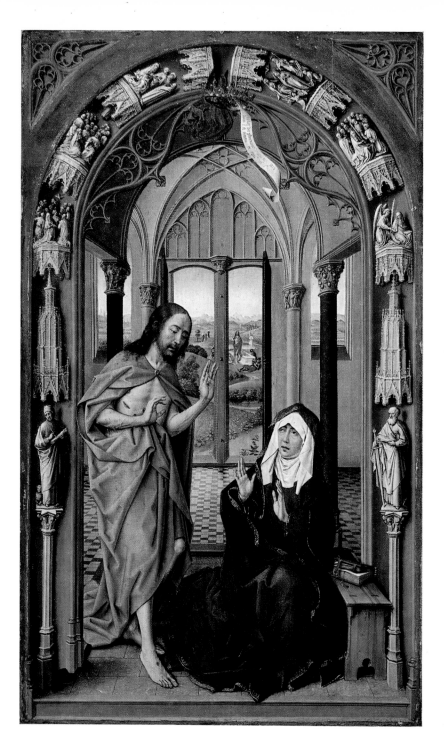

ROGIER VAN DER WEYDEN

Flemish, about 1400–1464

Christ Appearing to His Mother

Tempera and oil on wood, 25 × 15 in.
Bequest of Michael Dreicer, 22.60.58

According to legend, the first action of the risen Christ was to visit his mother, as promised. The tears are still on her cheeks as he greets her. The Resurrection is seen through the doorway. Two carved capitals show Old Testament events that prefigured Christ's triumph over death: David killing Goliath, and Samson killing a lion and carrying away the gates of Gaza. Statues of St. Mark and St. Paul stand on either side and the reliefs around the arch represent episodes in the Virgin's later life. The first, at the upper left, shows the three Marys giving the account of their visit to the sepulcher; below, the Ascension and Pentecost. On the right, from the bottom, the annunciation of the Virgin's death, the Dormition, and the Coronation.

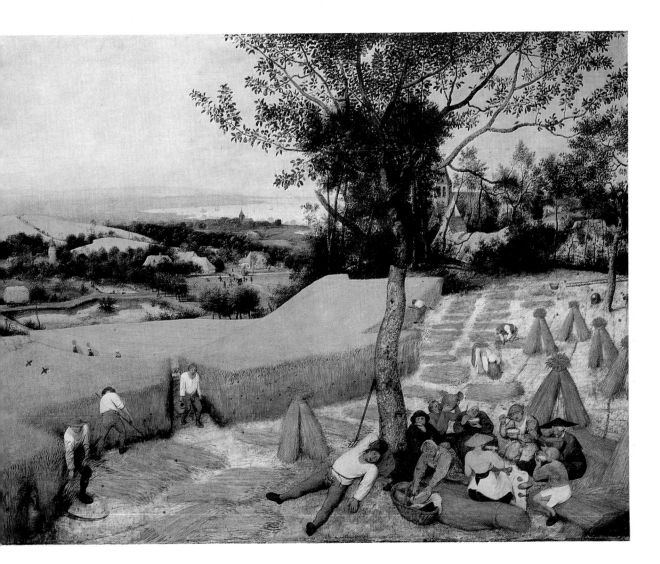

PIETER BRUEGEL THE ELDER

Flemish, active by 1551, d. 1569

The Harvesters

Oil on wood, 46¹/₂ × 63¹/₄ in.
Signed and dated (lower right)
 BRVEGEL/LXV (for 1565)
Rogers Fund, 19.164

This picture is one of a series illustrating the seasons. It shows a hot, hazy midsummer day, perhaps near Lake Geneva. The oddly colored landscape is strangely fascinating, but it is the human beings who mean most. Bruegel had a nearly miraculous ability to put down what he saw; the utter relaxation of the sleeping man, the movement and facial expression of the man cutting bread, the stance of the woman gathering up a bundle of grain are all absolutely convincing. The attitudes of the people in the remote fields are as sure and true as those of the harvesters at their meal under the pear tree. Yet the picture could not be further away from humdrum naturalism; like everything Bruegel painted or drew it is pure magic.

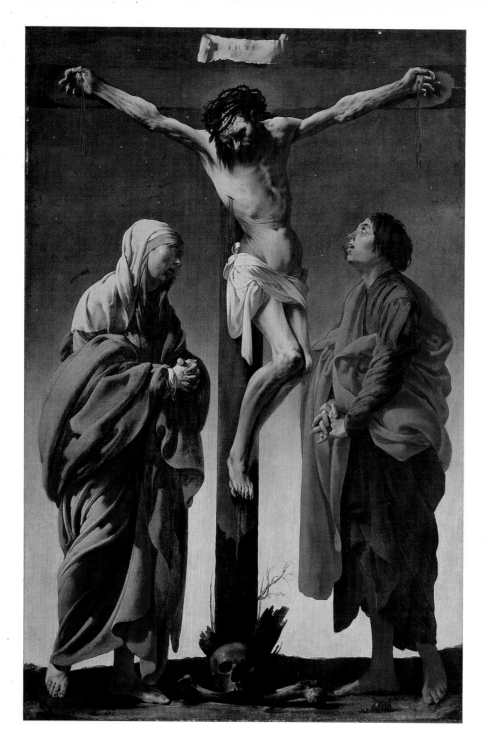

HENDRICK TERBRUGGHEN

Dutch, 1588–1629

The Crucifixion
with the Virgin and St. John

Oil on canvas, 61 × 40¼ in.
Signed and dated (lower center, on cross):
 HTB fecit 162–
Funds from various donors, 56.228

As a young man, Terbrugghen went from Utrecht to Rome, where he saw the mature works of Caravaggio, who was then putting Italian peasants with dirty feet into his religious paintings. Terbrugghen has used Dutch peasants as the Virgin and St. John here, but the ghastly realism of the corpse, with its green-toned face and belly, is more abhorrent than anything painted in Italy. The intensity of St. John's anguish, expressed by his open mouth and twisted hands, is made even more poignant by his plain face and red nose. Yet there is something beyond realism here. The strange, starry brown sky and the low horizon heighten the impression of an almost unbearable supernatural event.

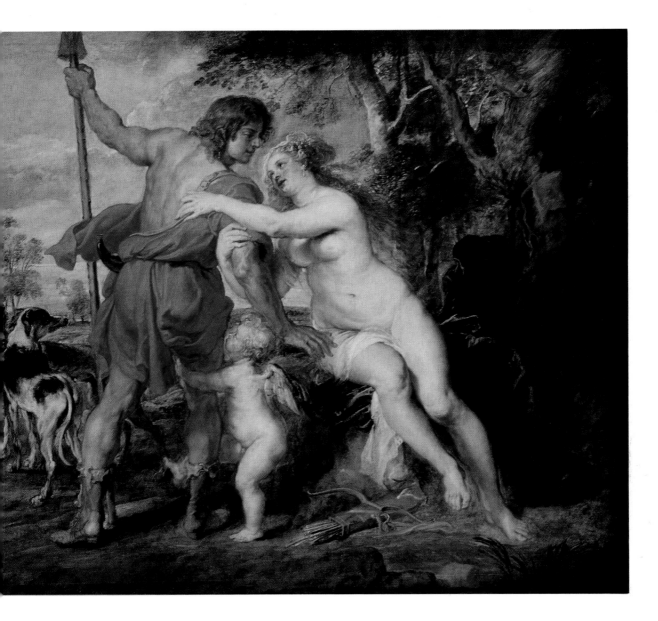

PETER PAUL RUBENS

Flemish, 1577–1640

Venus and Adonis

Oil on canvas, 77¹/₂ × 94⁵/₈ in.
Gift of Harry Payne Bingham, 37.162

A favorite subject of artists in the sixteenth and seventeenth centuries was the vain attempt by Venus to keep her lover, Adonis, from going hunting and meeting his death at the tusks of a boar. When Rubens painted this version, which is entirely by his own hand, in the last decade of his life, he certainly had in mind similar pictures by Titian and Veronese, but he designed it in a typically baroque manner. The great, turning figures dominate the canvas in a huge triangle: Adonis, pivoting on his firmly grasped spear, will in another instant throw off the beautiful, entangling arms and be on his way to his death. The light of the rising sun tinges the lovingly painted nude bodies with a delicate pink.

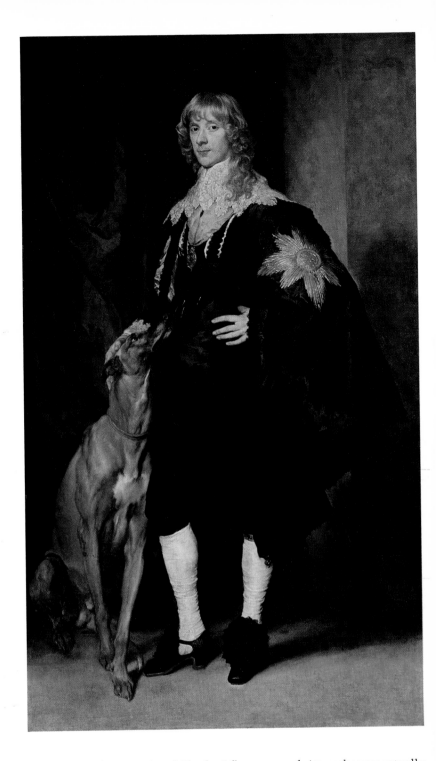

ANTHONY VAN DYCK

Flemish, 1599–1641

*James Stuart, Duke of Richmond
and Lennox* (1612–1655)

Oil on canvas, 85 × 50¼ in.
Gift of Henry G. Marquand, 89.15.16

Van Dyck's portraits of Charles I flatter a royal sitter who was actually not very imposing. Possibly the same was true of Charles's cousin and protégé, the young man depicted here. Certainly Van Dyck has used all the tricks of the trade to give him elegance and a commanding presence; the ratio of his head to his body is one to seven, as in a fashion plate, instead of one to six, the average in life. The noble dog, stretching its great body against its master's, also emphasizes the height and aristocratic bearing of the duke.

FRANS HALS

Dutch, after 1580–1666

Portrait of a Man

Oil on canvas, 43½ × 34 in.
Gift of Henry G. Marquand, 91.26.9

Hals was a prolific portraitist, so one can assume that he provided what his unpretentious bourgeois customers wanted: a good likeness without too many sittings, at a reasonable price. Probably few of them realized how much skill was needed to produce a deceptively simple picture like this one. The pose is striking, though natural, and there is an effective contrast of black against gray. Close to, all the brush-strokes in the white linen are visible; they can even be counted in the ribbons at the man's waist. Yet, at a distance, everything falls into place, the spectator's eye unconsciously doing the work of making coherent, "readable" wholes out of the sparse slashes and dashes. This was the challenging technique that so impressed nineteenth-century painters, especially Manet and Sargent.

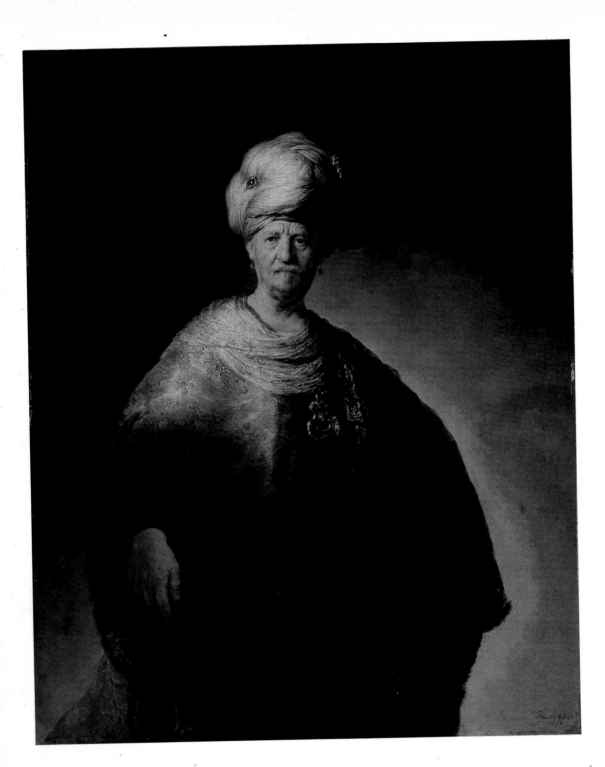

REMBRANDT HARMENSZ. VAN RYN

Dutch, 1606–1669

The Noble Slav

Oil on canvas, 60¹/₈ × 43³/₄ in.
Signed and dated (lower right): RL van Rijn/
1632 (Rembrandt of Leyden van Rijn)
Bequest of William K. Vanderbilt, 20.155.2

The title is a piece of nineteenth-century romanticism, for the model was certainly neither noble nor Slavic. Rembrandt, a highly successful portraitist at this period of his life, enjoyed painting members of his family and other ordinary people wearing rich and exotic costumes; the pictures are carried out with great gusto and bravura, as if the artist were exulting in his prowess. Although he has shown every wrinkle in this old man's face and every hair in his mustache, there is nothing niggling about the stately figure. In the penetrating eyes there is even a hint of the inner life that would later become for Rembrandt the real subject of every portrait he painted.

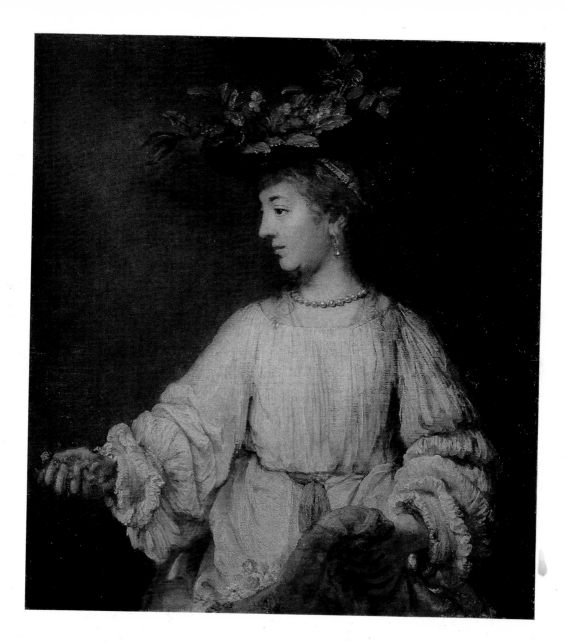

REMBRANDT

Flora

Oil on canvas, 39³/₈ × 36¹/₈ in.
Gift of Archer M. Huntington in memory of
his father, Collis Potter Huntington,
26.101.10

A collector in Amsterdam owned a Flora by Titian that Rembrandt certainly remembered when he painted his own about 1650. He has dressed his model up with shiny leaves and pink flowers on a great black hat, a yellow apron that looks as if it were filled with light as well as blossoms, and a full-sleeved blouse that falls into elaborate crinkly folds. One can almost feel the joy with which Rembrandt worked on these crinkles—painting them white, indeed, but full of touches of pink, blue, and green. The sitter is certainly no goddess, and she is very different from Titian's lush Venetian beauties; she seems a real person—modest, gentle, and good—and this is perhaps a likeness of Rembrandt's first wife, Saskia.

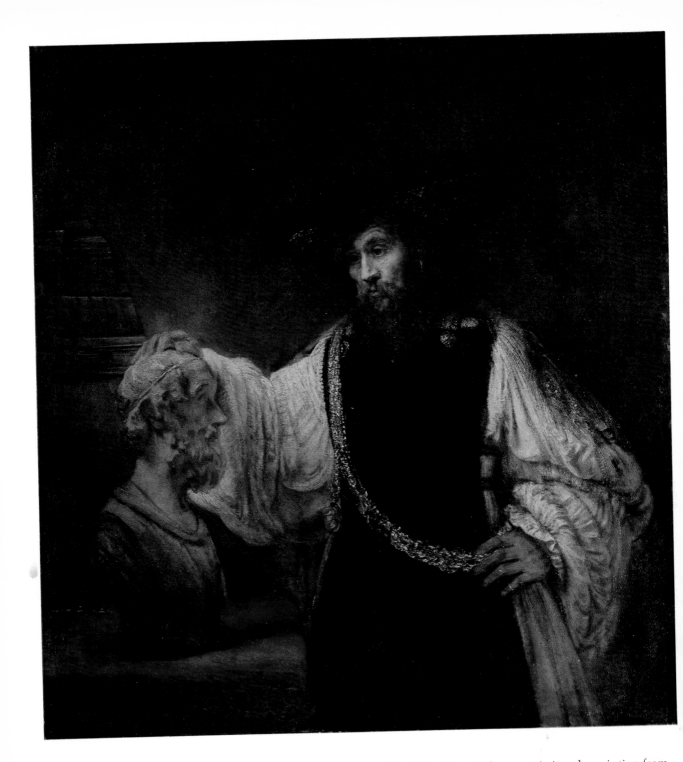

REMBRANDT

*Aristotle Contemplating
the Bust of Homer*

Oil on canvas, 56½ × 53¾ in.
Signed and dated (lower left, base of bust):
 Rembrandt f. 1653
Purchased with special funds and gifts of
 friends of the Museum, 61.198

Don Antonio Ruffo of Messina, Sicily, commissioned a painting from Rembrandt listed in the catalogue of his collection as "Aristotle holding one hand on a statue." The bust is that of Homer, but what Rembrandt painted is not merely a man looking at a marble head, but the greatest of all philosophers thinking about the greatest of all poets. It is interesting to compare Aristotle's sleeves with those of Flora and with the turban of the Noble Slav. Rembrandt worked on the turban painstakingly and handled Flora's sleeves with absolute mastery, but when he painted Aristotle his technical ability had reached such a height of virtuosity that it is no longer conspicuous. What matters is Aristotle's thought, not his costume; what the picture expresses, not how it was done.

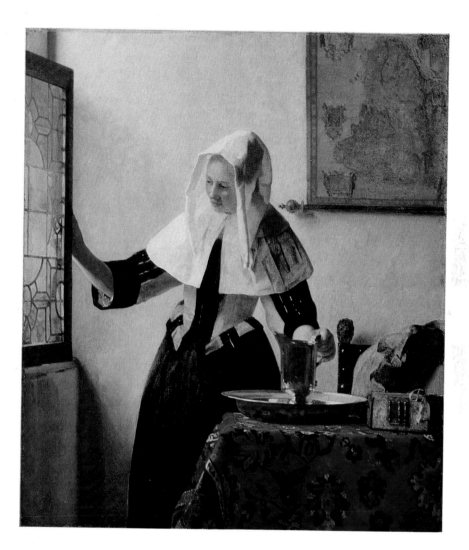

JAN VERMEER

Dutch, 1632–1675

Young Woman with a Water Jug

Oil on canvas, 18 × 16 in.
Gift of Henry G. Marquand, 89.15.21

Many literary attempts have been made to account for the perfection of Vermeer's best works, but one art cannot be explained with the tools of another. It is impossible even to describe these pictures adequately. Light, color, and composition in depth—always of the first importance in good seventeenth-century Dutch paintings—can be endlessly analyzed. Here, for instance, one can say that it is the sharp fold of the rug that establishes the space between the spectator and the table, that the tabletop and the lower edge of the window mark another step back, and that there is yet more space before the rear wall is reached. A harmonious relationship is felt among these spaces, but the ineffable timelessness and serenity of the picture still remain inexplicable.

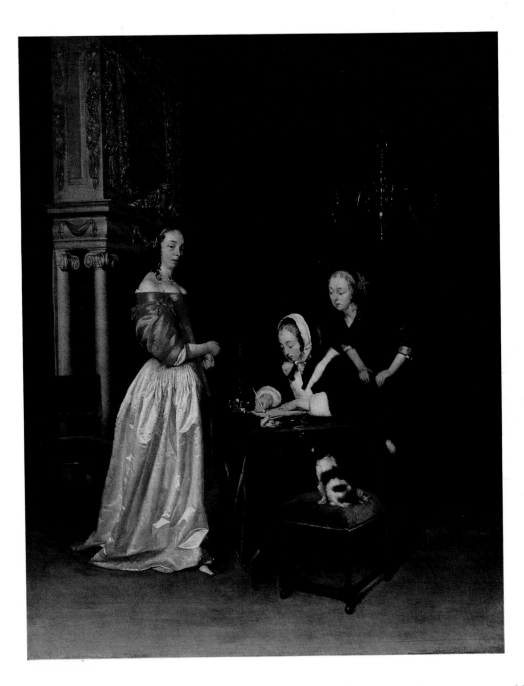

GERARD TERBORCH

Dutch, 1617–1681

Curiosity

Oil on canvas, 30 × 24¹/₂ in.
The Jules Bache Collection, 49.7.38

Terborch's ability to describe the clothes and homes of his well-to-do patrons while he slyly depicted witty domestic situations made him very popular during his lifetime. He was particularly successful with lustrous fabrics, like the silk satin skirt of the standing woman here. The rich costumes and the furnishings of this typically Dutch room provide some interesting comparisons. The gilded baroque chimney-piece is made more conspicuous by the plain floor. There are handsome accessories, like the brass chandelier, but the furniture is simple. "Rich, not gaudy," might be the approving comment of the three women. The servingmaid peers cautiously to see what the lady is writing; the alert, well-trained little dog waits comfortably and patiently on its stool for the letter to be finished.

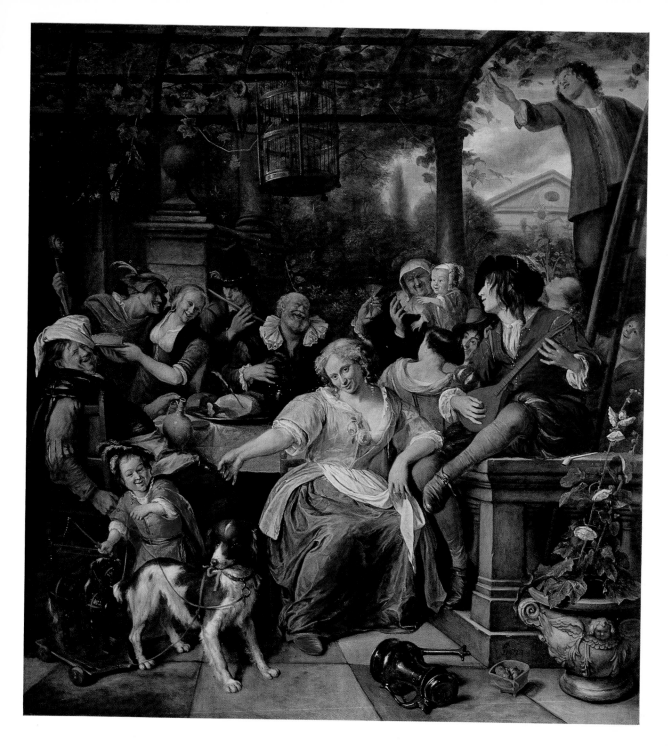

JAN STEEN

Dutch, 1626–1679

Merry Company on a Terrace

Oil on canvas, 55¹/₂ × 51³/₄ in.
Signed (lower right): J Steen
Fletcher Fund, 58.89

Steen shows quite another aspect of Dutch seventeenth-century life from the ordered one seen in the works of Vermeer, Terborch, and Metsu. Though a prolific painter, he also operated breweries and owned a tavern. Here he has shown himself as the fat man sitting at the left, holding a jug. Gaiety and noise (including music) prevail. Steen's outstanding quality has been described as "natural light-heartedness," but he has depicted this good-humored uproar with the most refined color and careful composition, centering on the agreeably tipsy fair-haired woman, perhaps his young second wife, in the brilliant, pale blue dress. The owl near the birdcage, usually a symbol of evil or obstinate ignorance, seems here to be merely a pet.

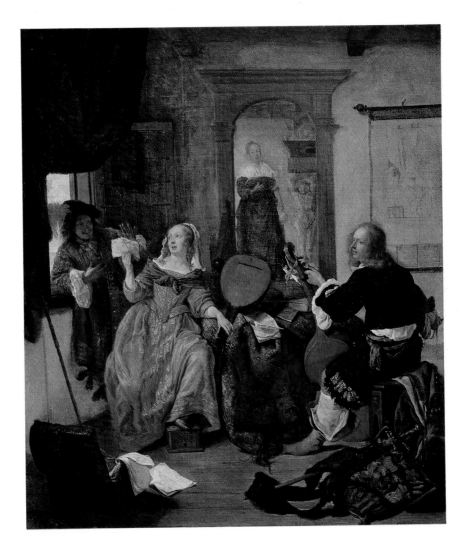

GABRIEL METSU

Dutch, 1629–1667

The Music Lesson

Oil on canvas, 24¹/₂ × 21³/₈ in.
Signed and dated (lower left, on paper):
 G. Metsu/1659
Gift of Henry G. Marquand, 91.26.11

It has been suggested that the subject here is man as love's prisoner, the chief clue being the carved figure seen through the open door—a chained slave, doomed to carry his burden forever. Music and love, of course, are constant companions in art and literature, and one can well imagine that both men have more than their notes on their minds. Music is dominant throughout; the man at the window will probably sing from the book the woman is handing him, and Metsu's signature is written beneath a stave of the music. There are charming details in the untidy, crowded scene, such as the elegant shapes of the lute and of the viol that the man on the right is tuning.

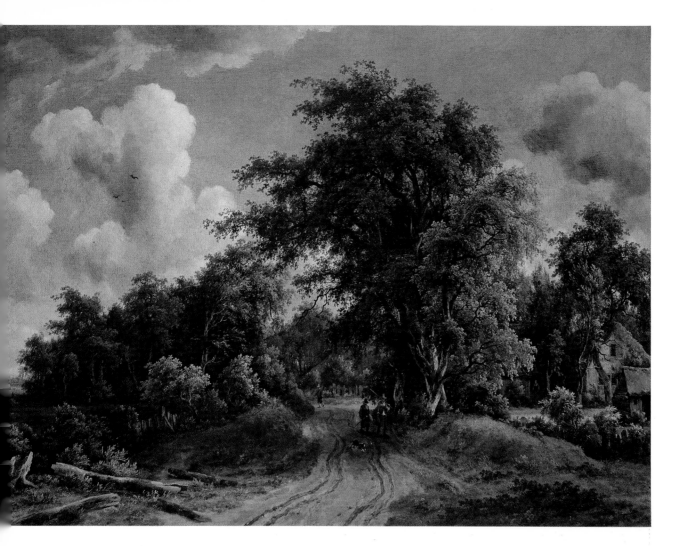

MEINDERT HOBBEMA

Dutch, 1638–1709

A Woodland Road

Oil on canvas, 37¼ × 51 in.
Signed (lower right): M. Hobbema
Bequest of Mary Stillman Harkness, 50.145.22

This picture is extraordinarily action-filled for Hobbema, with its wind-swept trees and towering masses of moving clouds. The fallen logs in the left foreground have also an unusually dramatic quality for this artist. He generally laid out his calm landscapes in alternating horizontal zones of light and shadow, extending in depth from the foreground into the remote distance. These zones, present here, are broken up by hillocks and clusters of trees; the eye moves up and down and in and out until it reaches the final zone of brightness at the low horizon. Above are the piled-up clouds, not mechanically echoing the tree clumps below, but sufficiently in harmony with them that the view, apparently so casual, is organized into an eminently satisfying composition.

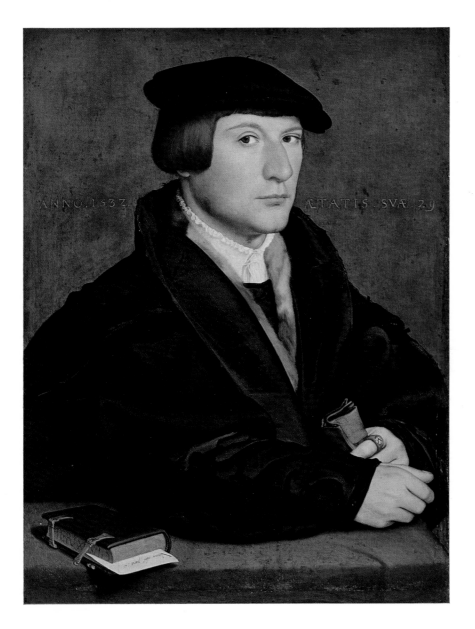

HANS HOLBEIN THE YOUNGER

German, 1497/98–1543

Portrait of a Member of the Wedigh Family

Tempera and oil on wood, 16¹/₂ × 12¹/₂ in.
Inscribed (background): ANNO. 1532. AETATIS.
 SVAE. 29. (In the year 1532, aged 29); (cover
 of book): H.H.; (side of book): HER [?] WID;
 (paper in book): Veritas odiu[m] parit
Bequest of Edward S. Harkness, 50.135.4

When Holbein, persuaded by Erasmus, went to England, he found clients among the colony of German merchants in London. The arms on the ring worn by this young man and the lettering on the side of his book indicate that he is a member of a Cologne trading family named Wedigh; presumably he was their representative in England. The cynical words from Terence are no doubt his personal motto. Certainly they do not apply to this picture, for it was the kind of truth displayed here that won Holbein general admiration rather than hatred, including a position as court painter to Henry VIII. The superb draughtsmanship characteristic of this artist can be seen in every perfect line of this elegant portrait.

SPANISH SCHOOL

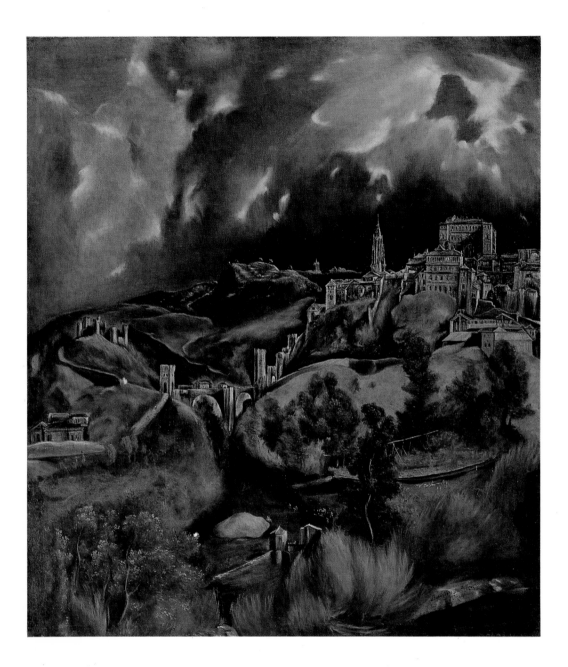

EL GRECO
(DOMENICOS THEOTOCOPOULOS)

1541–1614

View of Toledo

Oil on canvas, 47³/₄ × 42³/₄ in.
Signed in Greek (lower center): Domenicos
 Theotocopoulos made it
The H. O. Havemeyer Collection
Bequest of Mrs. H. O. Havemeyer, 29.100.6

El Greco, "the Greek," came from Crete to Spain via Italy in his thirties. He settled in Toledo and remained there the rest of his life, enjoying great popularity with ecclesiastical patrons. This view of his adopted city, his only true landscape, belonged after his death to Jorge Manuel, his son, suggesting that it had been painted for the artist's own satisfaction, not as a commission. The buildings are recognizable, though interchanged, and the viewpoint is identifiable, yet this is no earthly city. The foreground, irrigated by the Tagus flowing beneath the Alcántara bridge, is fertile and green; the distant landscape, barren and threatening. There is no visible source for the light that whitens the edges of the clouds and strikes the buildings with such dramatic emphasis.

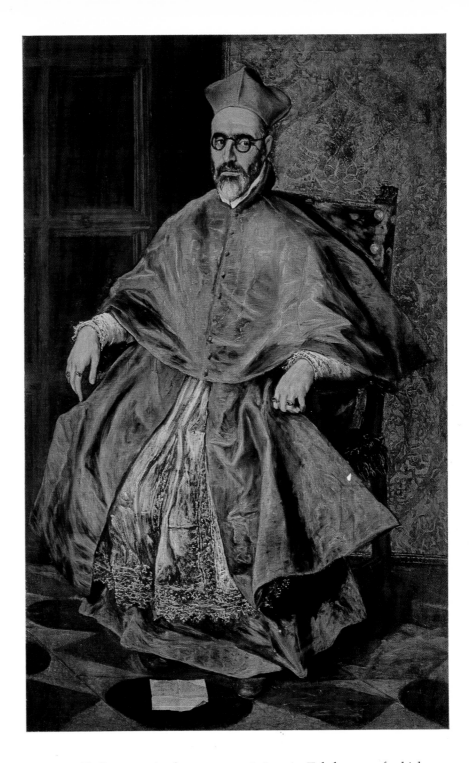

EL GRECO

*Cardinal Don Fernando Niño
de Guevara* (1541–1609)

Oil on canvas, 67¹/₄ × 42¹/₂ in.
Signed in Greek (lower center): Domenicos
 Theotocopoulos made it
The H. O. Havemeyer Collection
Bequest of Mrs. H. O. Havemeyer, 29.100.5

El Greco received many commissions in Toledo, one of which was
this portrait of a Grand Inquisitor. The very name of his office casts a
chill today, though to his Spanish contemporaries it would have indi-
cated merely that the cardinal was an important and useful servant
of the Church. But even when the connotations of "inquisitor" have
been discounted, the portrait still generates awe. The black circles of
the spectacle rims give the eyes a piercing, sinister look; the straight
line of the mouth and the tensed left hand strengthen a terrifying im-
pression of the man's uncompromising fanaticism. The predominance
of red in the picture reinforces the fear the sitter inspires.

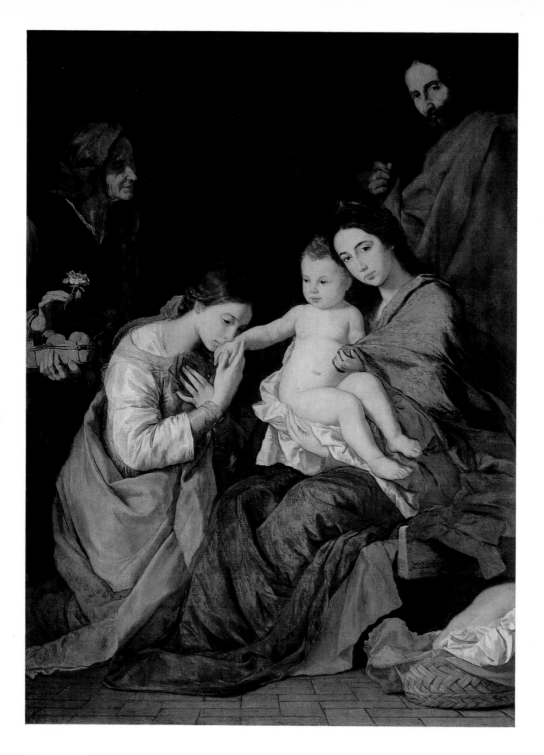

JUSEPE RIBERA

1591–1652

The Holy Family with St. Catherine

Oil on canvas, 82¹/₂ × 60³/₄ in.
Signed and dated (lower right): Jusepe de
 Ribera español/accademico Rono./F. 1648
 (Jusepe de Ribera, Spaniard, Roman
 Academy, made it, 1648)
Samuel D. Lee Fund, 34.73

Ribera spent his entire adult life in Italy, living in Naples from 1616, but this city was then a Spanish possession and many of his paintings were made for Spanish patrons. His double allegiance is indicated in his signature: a Spaniard, and a member of the Roman Academy of St. Luke. This Holy Family has no halos and the kneeling saint no attribute. She is probably St. Catherine, even though she is not receiving a wedding ring from the Child. The sacred character of the figures is suggested only by their grace, beauty, and tenderness. Even St. Anne, portrayed as a haggard old woman, holds her rose with the utmost delicacy.

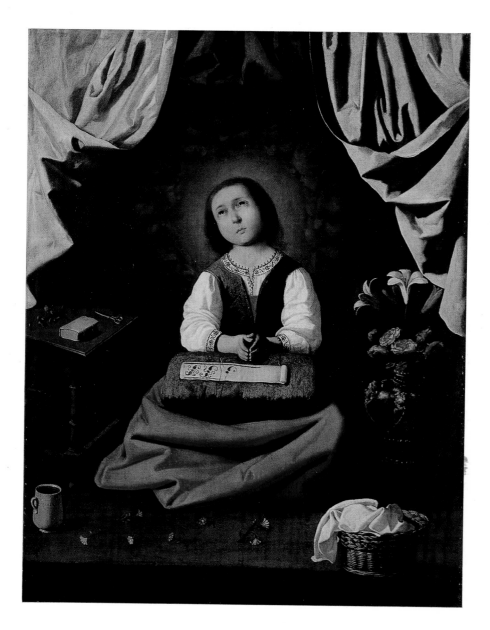

FRANCISCO DE ZURBARAN

1598–1664

The Young Virgin

Oil on canvas, 46 × 37 in.
Fletcher Fund, 27.137

According to legend, the Virgin went as a child to live in the Temple, where she was distinguished by her piety and her skill in needlework. She is shown here at an early age interrupting her typically Spanish blackwork embroidery to contemplate some heavenly mystery. A dimly seen circle of fiery cherubim takes the place of a halo and contrasts with the matter-of-fact realism of the accessories. Some of these, such as the roses and lilies, are standard symbols of the Virgin; others, such as the scissors, have no well-known meanings. It is often said that the Spanish character unites the realism of Sancho Panza with the idealism of Don Quixote. Something of the same curious combination is frequently seen in Spanish paintings.

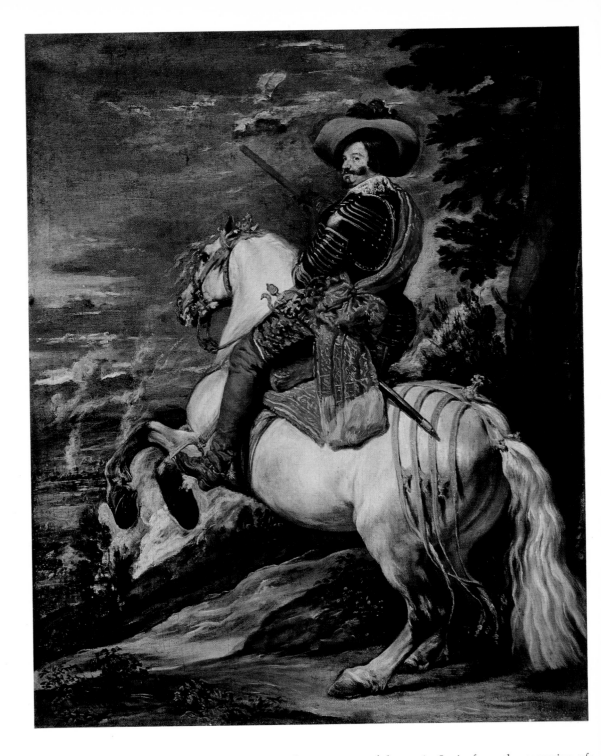

DIEGO RODRIGUEZ DE SILVA
Y VELAZQUEZ

1599–1660

*Don Gaspar de Guzmán, Count Duke
of Olivares,* 1587–1645

Oil on canvas, 50³/₄×41 in.
Fletcher Fund, 52.125

Olivares was the most powerful man in Spain from the accession of
Philip IV in 1621 until 1643, when the king banished him. Though
a statesman, not a soldier, he is shown by Velázquez as a command-
ing officer, with dimly seen armies fighting in the distance. Olivares
presumably chose this setting; a contemporary wrote that he had all
the characteristics of a general except that he had never been on a
battlefield. The upright figure dominates the great X of the composi-
tion, formed by the diagonals of the horse's body crossing the upward
sweep of the landscape from the lower left to the upper right corner.
Through the movement and spirit of the vividly painted horse, Veláz-
quez has emphasized the confident mastery of the rider.

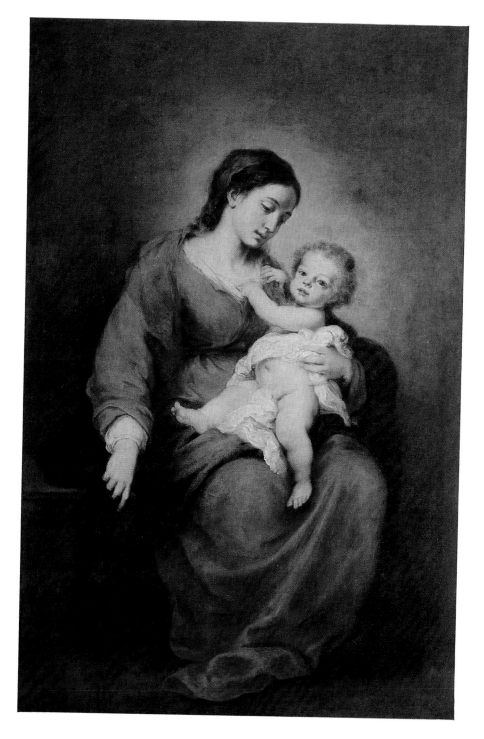

BARTOLOME ESTEBAN MURILLO

1617–1682

Madonna and Child

Oil on canvas, 65¼×43 in.
Rogers Fund, 43.13

Murillo painted the Virgin and Child over and over again; his su-
premely beautiful but always human figures were what every Spanish
church and pious family wanted over its altars. This example was in
the chapel of the Santiago family until 1808. Except for the extreme
good looks of both figures, this could be an actual mother and son.
The Virgin is almost too perfect to be true, but the model must have
been a real woman, since she appears in other paintings by Murillo.
The Child, equally beautiful, with his golden hair and huge dark eyes,
is only a slightly idealized, though younger, version of the handsome
beggar boys of Seville, whom Murillo frequently painted.

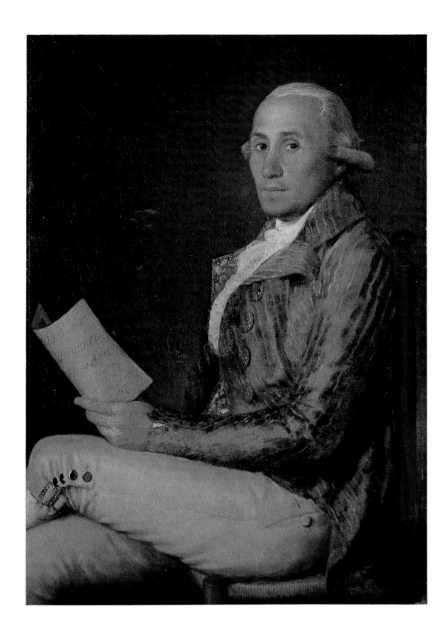

FRANCISCO DE GOYA

1746–1828

Don Sebastián Martínez

Oil on canvas, 36⁵/₈ × 25⁵/₈ in.
Signed and dated (on paper): Dn Sebastian/
 Martinez/Por su Amigo/Goya/1792
Rogers Fund, 06.289

Don Sebastián was a lawyer and government official in Cadiz. The year after this portrait was painted, Goya, then very ill, stayed with him. A warm red underpainting shows beneath the thinly painted blues and greens of the sitter's coat and the brilliant white of his shirt frill, giving vibrancy to the cool harmony of the color scheme. Natural friendly affection can be sensed behind the refinement, restraint, and intelligence of Don Sebastián's features and expression. Goya did not treat all of his clients as if he were an *amigo;* some, we often feel, he must have disliked, even despised. We find him here in a rarer mood, combining friendliness and appreciation with his usual frankness and perspicacity.

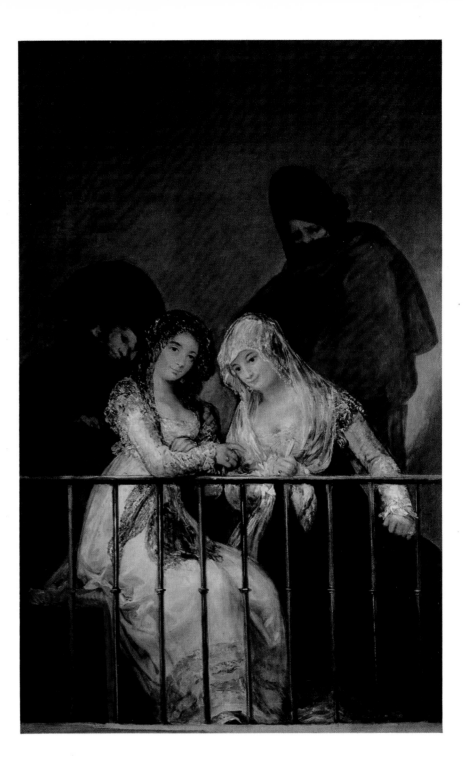

GOYA

Majas on a Balcony

Oil on canvas, 76³/₄ × 49¹/₂ in.
The H. O. Havemeyer Collection
Bequest of Mrs. H. O. Havemeyer, 29.100.10

The *maja* of Madrid and her male counterpart, the *majo*, belonged to the working class, not the gentry. They were young folk who carried themselves with a certain dash; their manners were free and easy and their costumes stylish, distinctive, and somewhat flamboyant. Goya painted many lovely girls of this type. Here two of the glowing beauties sit on a balcony, as if laughing at the passers-by, with two men silhouetted behind them. Such an everyday scene might have been pictured by any eighteenth-century genre painter on a small scale, but Goya has made it life-size. His masterly use of impasto and brush- and knife-work can be seen in such sparkling passages as the left sleeve of the girl on the right.

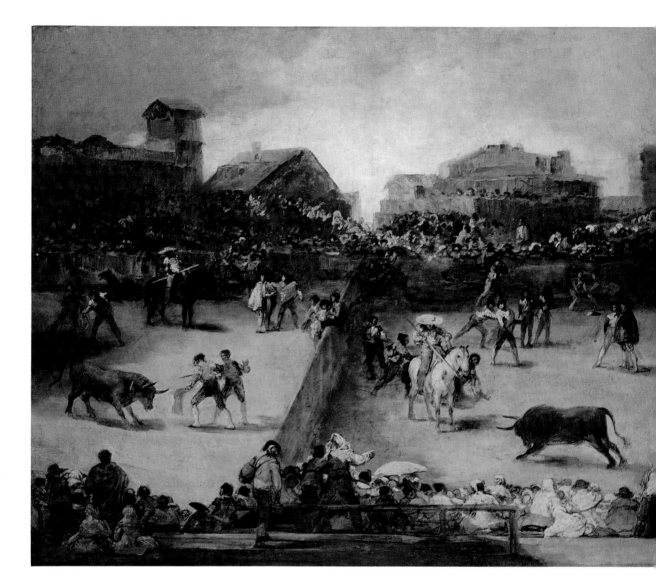

GOYA

The Bullfight

Oil on canvas, 38³/₄ × 49³/₄ in.
Catharine Lorillard Wolfe Collection, 22.181

Fifty years ago, when this painting looked astonishingly modern, it was compared to "an illustration in the National Geographic Magazine or the Pictorial News parts of a moving picture entertainment." It is, however, by no means a casual snapshot of a bullring, but instead a most careful composition. Goya has shown another of these divided rings in a lithograph; such an arena enabled him to illustrate several incidents of the highly popular sport on a single canvas. The topmost row of the sharply descending ranks of seats in the foreground is filled with markedly individual figures, from the white-clad couple sitting stolidly in the shade on the left to the three boon companions on the far right.

FRENCH SCHOOL

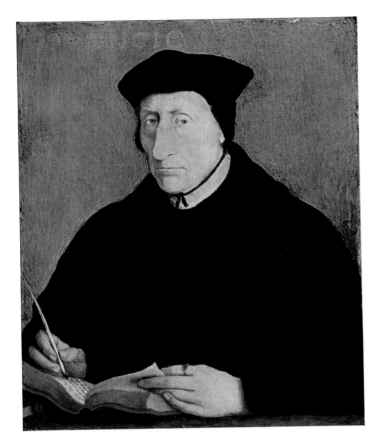

JEAN CLOUET

Active by 1516, d. 1540

Guillaume Budé, 1467–1540

Tempera and oil on wood, 15⅝ × 13½ in.
Inscribed in Greek (on book): It may seem a
 great thing to realize one's desires, but truly
 the greatest thing is not to desire what one
 should not; (across top of panel): ORONCIO
 (a later, erroneous identification of the sitter)
Maria DeWitt Jesup Fund, 46.68

Guillaume Budé was a distinguished scholar, called by Erasmus the
"marvel of France." The Greek inscription on this panel, Stoic in
sentiment, is an indication that the sitter was an uncommonly learn-
ed humanist; he can be identified as Budé from his resemblance to
early engravings inscribed with his name. Budé recorded that "Master
Genet Clouet" had made his likeness; since Jean Clouet was the king
of France's chief painter and Budé was an ambassador and librarian to
Francis I, this artist is indeed the most likely person to have painted
this portrait.

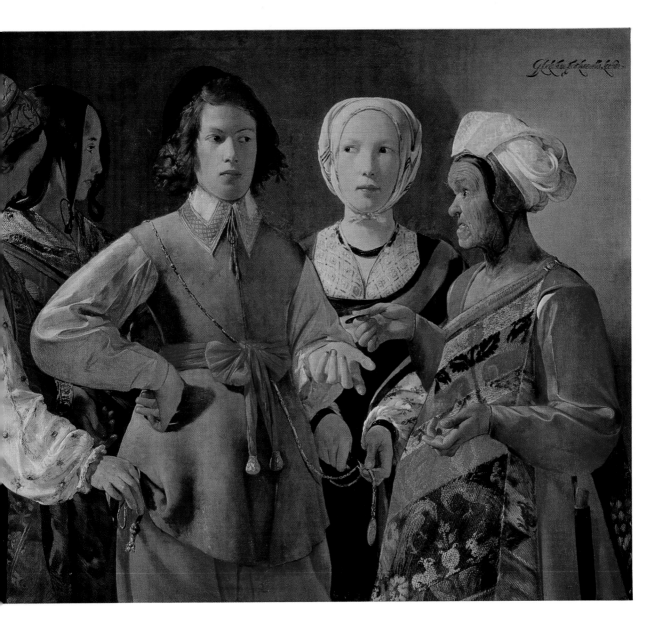

GEORGES DE LA TOUR

1593–1652

The Fortuneteller

Oil on canvas, 40¹/₈ × 48⁵/₈ in.
Signed (upper right): G. de La Tour Fecit
 Lunevilla Lothar (Georges de la Tour made
 it at Lunéville in Lorraine)
Rogers Fund, 60.30

Lunéville, a small town near Nancy, was the capital of the duchy of Lorraine in the seventeenth century. Here lived Georges de La Tour, painter to the court, and highly successful. But he and his works were forgotten after his death, and only in the 1930s was it realized how original an artist had flourished in this remote corner of France. In this picture, a young man—conceited, foolish, and suspicious (but not sufficiently so)—is being cheated by gypsies. The ugly old woman holds a silver amulet and, in a kind of trance, tells his fortune. He hangs on her words—and her companions rob him. There is an atmosphere of awe and silence, of folly and wickedness, but the incident is not related in tragic or moralizing terms.

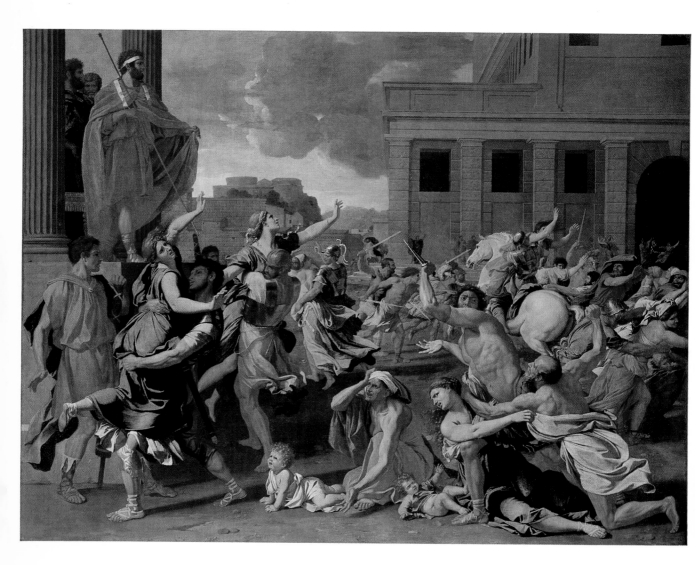

NICOLAS POUSSIN

1593/94–1665

The Rape of the Sabine Women

Oil on canvas, 60⅞ × 82⅝ in.
Harris Brisbane Dick Fund, 46.160

Poussin painted this work in Rome, where he spent most of his life. Following Plutarch in his telling of the story, he shows Romulus between the columns of a temple in the Forum, giving the prearranged signal with his cloak for the Romans to carry off the unmarried Sabine women. One wife and mother has been seized by mistake; her two babies, with their old nurse, sprawl in the foreground. The Sabine men, duped into coming unarmed to what they thought would be a religious celebration, flee on the right. In the middle distance, center, a Sabine girl walks off amicably enough with her captor, foreshadowing the happy ending to come. Poussin's intense coloring suits the violence of the event.

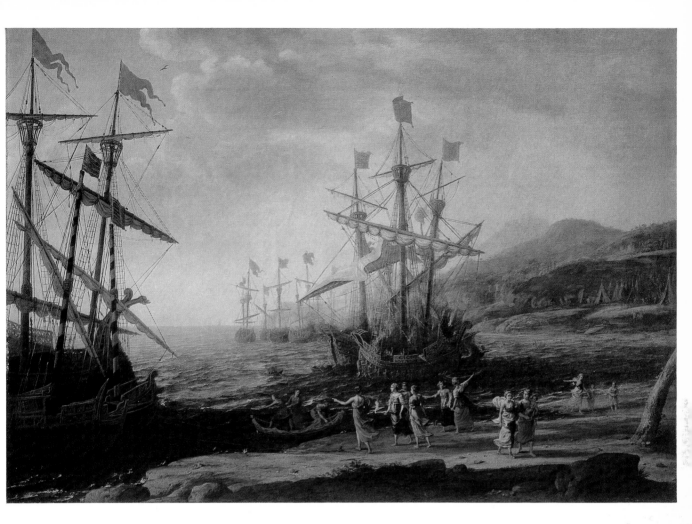

CLAUDE LORRAIN (CLAUDE GELLEE)

1600–1682

*The Trojan Women Setting Fire
to their Fleet*

Oil on canvas, 41³/₈ × 59⁷/₈ in.
Fletcher Fund, 55.119

Virgil tells the story of this painting in the fifth book of the *Aeneid*.
The Trojan fleet left Carthage and came to Sicily, where Aeneas's
father, Anchises, was buried, and the Trojan men celebrated the an-
niversary of his funeral by games on shore. But the women, exhausted
by seven years of wandering, were inspired by Juno and Iris to burn
their "beautifully painted" ships, so that the exiles would be forced
to settle where they had landed. Aeneas, however, prayed to Jupiter,
who put out the fires with a rainstorm. This picture was made for
Girolamo Farnese, who had been papal nuncio in Switzerland. He
probably chose this unusual subject because he himself had suffered
the hardships of prolonged travel.

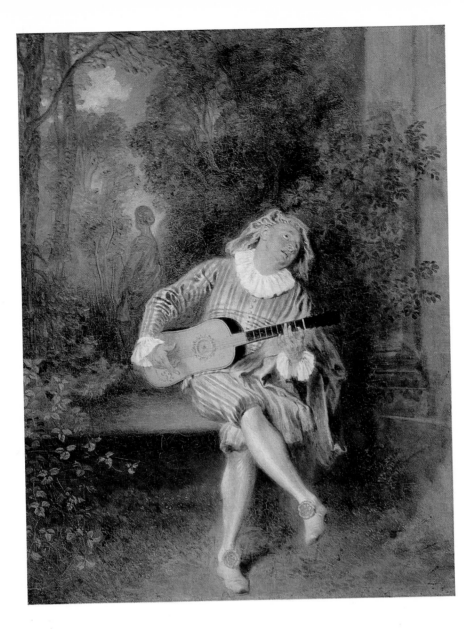

JEAN ANTOINE WATTEAU

1684–1721

Mezzetin

Oil on canvas, 21³/₄ × 17 in.
Munsey Fund, 34.138

Mezzetin was a character in the commedia dell'arte, a theatrical form in which, as in a comic strip or television serial, the people are always the same, though involved in different situations. A gentleman's servant in a striped costume, Mezzetin played the guitar, was given to sly tricks, and was usually unlucky in love. Watteau owned costumes for these commedia roles and liked to paint his friends dressed up in them; he transformed them into denizens of a quiet, gentle world of wistful make-believe. He has shown Mezzetin as a melancholy musician, full of pathos, but without sentimentality or staginess. The setting, with its soft, dense foliage and dimly seen statue, is in complete harmony with the muted, tender emotion of the player and his tune.

FRENCH SCHOOL

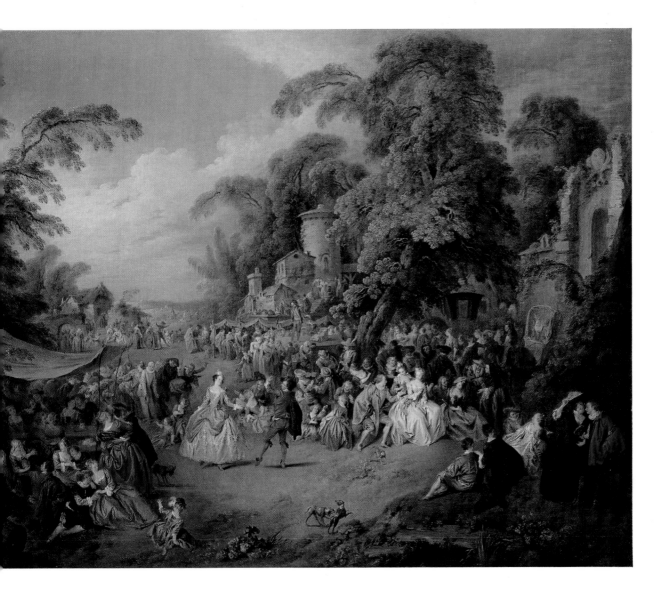

JEAN BAPTISTE JOSEPH PATER

1695–1736

The Fair at Bezons

Oil on canvas, 42 × 56 in.
The Jules Bache Collection, 49.7.52

The annual fair at Bezons, a village near Versailles, was the subject of several paintings by Watteau and his followers, of whom Pater was among the most gifted. Here he has placed more than two hundred skillfully drawn figures in a picturesque, breezy landscape that only vaguely suggests the village. The company can also hardly be imagined as bearing much resemblance to eighteenth-century rural merrymakers; we are in a never-never land where everyone wears silk and no one misbehaves. Old people are hard to find in this crowd. The stars of a troupe of actors are dancing in a burst of sunlight; comics and clowns, masked or in motley, cluster behind them. There are children and dogs everywhere and a feeling of decorous gaiety prevails.

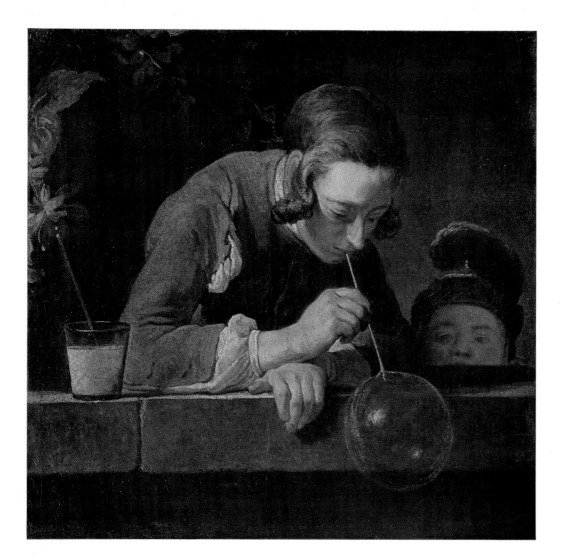

JEAN BAPTISTE SIMEON CHARDIN

1699–1779

Blowing Bubbles

Oil on canvas, 24 × 24⁷/₈ in.
Signed (lower left): J. Chardin
Catherine D. Wentworth Fund, 49.24

The subject of this picture is the age-old idea that the life of man is as brief as that of a soap bubble. Chardin has reduced it to its simplest terms. He makes us aware of the roundness of the bubble, the shape of the man's head, the pressure of his wrist on the back of his hand, of his arm on the stone ledge. The balanced composition and the restricted color scheme, with little emphasis on the iridescence of the bubble, contribute to the effect of stillness and seriousness, even solemnity. In another second the bubble will break and the man and the child will outlive it only for an insignificant length of time, but Chardin has recorded this trivial, evanescent moment as if it were eternal.

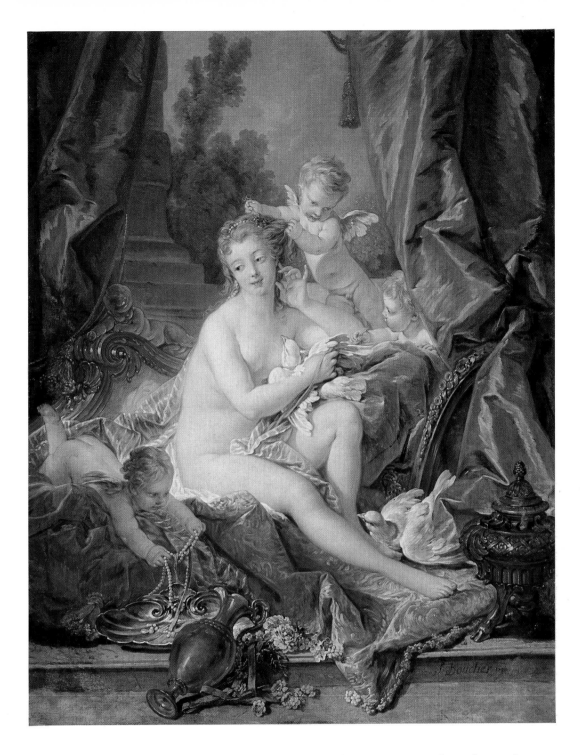

FRANCOIS BOUCHER

1703–1770

The Toilet of Venus

Oil on canvas, 42⁵/₈ × 33¹/₂ in.
Signed and dated (lower right): f. Boucher 1751
Bequest of William K. Vanderbilt, 20.155.9

In 1750 Madame de Pompadour commissioned Boucher to decorate her recently completed château of Bellevue. This painting and a companion piece of Venus bathing Cupid, now in the National Gallery, Washington, were probably made for her bathroom. It is hard to imagine a more appropriate setting for this delicately sensuous work. Boucher excelled in rendering the texture of such things as velvet, feathers, or hair, all of which are shown here in contact with the soft skins of the goddess and the babies attending her. He could be called the painter of the sense of touch. Venus, with her modishly powdered hair, is presumably a portrait of Madame de Pompadour, who was then thirty years old and for seven years had been *maîtresse en titre* to Louis XV.

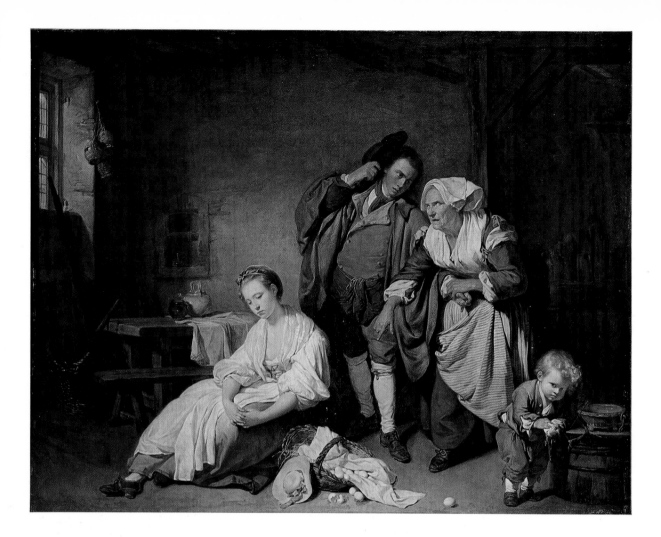

JEAN BAPTISTE GREUZE

1725–1805

Broken Eggs

Oil on canvas, 28³/₄ × 37 in.
Signed and dated (lower right, on barrel):
 Greuze f. Roma/1756 (Greuze made it in
 Rome 1756)
Bequest of William K. Vanderbilt, 20.155.8

When this picture was exhibited at the 1757 Paris Salon, it was described as: "a mother scolding a young man for having upset a basket of eggs which the servant girl was carrying to market; a child is trying to mend a broken egg. The little boy, who was playing with a bow and arrow and now attempts the impossible repair, is an allusion to the danger of playing with Cupid's darts." Greuze made the work for his patron, the Abbé Gougenot, a wealthy art lover and archaeologist, who had taken him to Rome and whose portrait Greuze also painted. The eggs in their basket and the girl's beribboned hat make an admirably rendered still life.

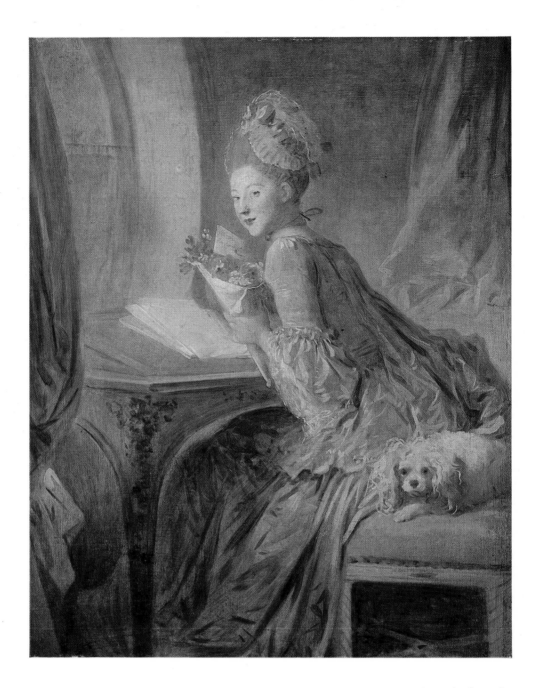

JEAN HONORE FRAGONARD

1732–1806

The Love Letter

Oil on canvas, 32³/₄ × 26³/₈ in.
Inscribed (on letter): A Monsieur mon Cavalier
 [or Cavallier]
The Jules Bache Collection, 49.7.49

The only carefully worked-out part of this canvas is the girl's face, the first thing to catch the eye. The brushwork becomes more and more rapid and free as it proceeds outward from this center of interest, and when it reaches the dog's ears and the ornamentation at the corner of the table it consists only of single strokes and squiggles. Furthermore, the whites of the cap, paper, and dog are dulled, so that the face is the brightest object in the picture. The girl is shown tucking a note to her lover into a bouquet of flowers; there is an effect of suddenly arrested movement, as if she had been caught in the act. The costume indicates that this lighthearted sketch was painted in the 1770s.

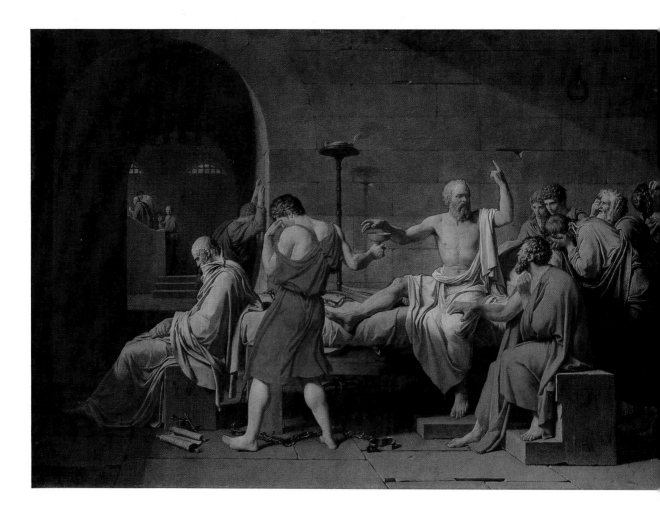

JACQUES LOUIS DAVID

1748–1825

The Death of Socrates

Oil on canvas, 51 × 77¼ in.
Signed (left, on block of stone): L. D; dated
 (left, on floor): MDCCLXXXVII; signed (right,
 on block of stone with owl): L. David
Catharine Lorillard Wolfe Collection, 31.45

The importance of David in the great change that came over French art in the late eighteenth century is well illustrated by this picture. It was exhibited in the Paris Salon of 1787, surrounded by adulatory portraits of the royal family and other works by rococo artists, where it can be truly said to have represented the wave of the future. All the high-minded seriousness of the Revolution that would break out two years later, all of that movement's self-conscious effort to attain the heights of the noblest Greek and Roman ideals, are foreshadowed here. Socrates, who was notoriously ugly, has been given the torso of an Achilles, and every actor displays dignity and restraint. The stately figures are arranged as if in a classical bas-relief.

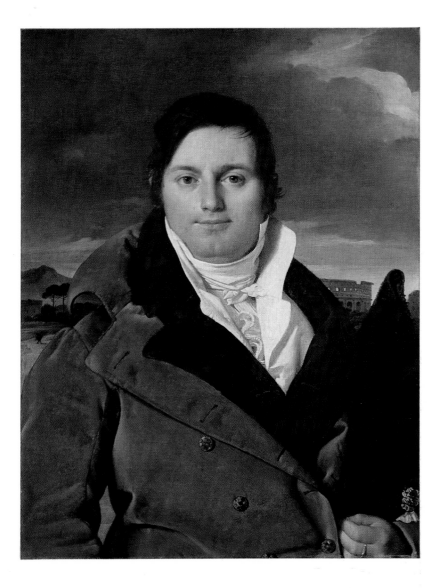

JEAN AUGUSTE DOMINIQUE INGRES

1780–1867

Joseph Antoine Moltedo

Oil on canvas, 29⅝ × 22⅞ in.
The H. O. Havemeyer Collection
Bequest of Mrs. H. O. Havemeyer, 29.100.23

Moltedo, a Corsican, was a prominent official and industrialist in his thirties when Ingres painted his portrait in Rome about 1812. The Colosseum and a typical landscape of the Campagna are seen in the background. Ingres has shown the sitter with an impassive, pale face against a threatening sky; his bearing suggests authority and absolute self-confidence. The precise intricacy of the lines of the costume demonstrates the artist's impeccable draughtsmanship and contrasts effectively with Moltedo's powerful features and fixed gaze. Ingres made many portraits, both in oil and in pencil, during his years in Rome, and they are among his most characteristic and successful works.

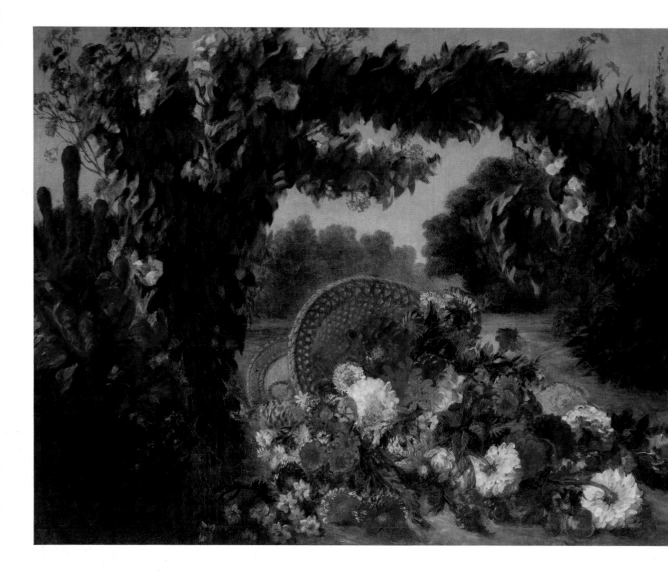

EUGENE DELACROIX

1798–1863

Basket of Flowers in a Park

Oil on canvas, 42¹/₄ × 56 in.
Bequest of Adelaide Milton de Groot
 (1876–1967), 67.187.60

Delacroix began to paint four large pictures of fruit and flowers in the autumn of 1848; he showed two of them, including this one, at the Paris Salon the following year. They were not sold and remained in his possession until his death. The term *still life,* even more its French equivalent *nature morte,* seems particularly inappropriate for this exuberant cascade of chrysanthemums and poppies, competing with each other in color and brilliance; their turbulence is like a waterfall or the confused mass of plunging bodies in a Last Judgment or a battle scene. A pastel drawing in the Metropolitan for the arch of morning-glories suggests that the picture is a combination of various studies from nature.

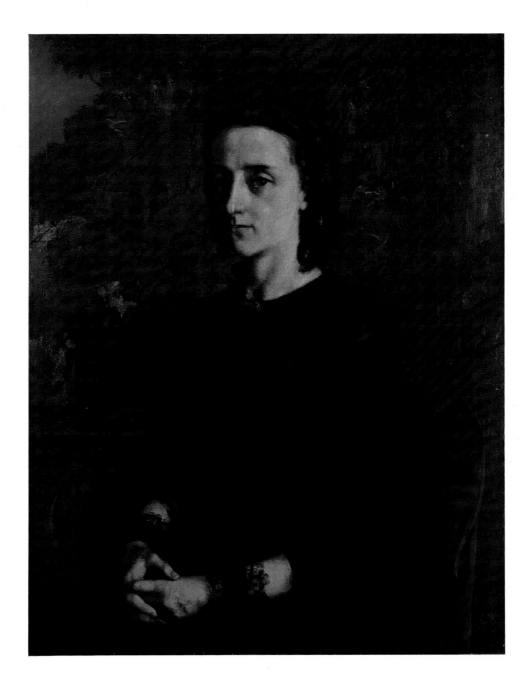

JEAN DESIRE GUSTAVE COURBET

1819–1877

Madame de Brayer

Oil on canvas, 36 × 28⅝ in.
Signed and dated (lower right): G. Courbet 58
The H. O. Havemeyer Collection
Bequest of Mrs. H. O. Havemeyer, 29.100.118

Nothing certain is known about Madame de Brayer; she is said to have been a Polish exile married to a Belgian. When she sat to Courbet in Brussels, he must have found her a tragic figure, for seldom has so somber a portrait been painted. Her stern, handsome face is half in deep shade and there are black shadows under the dark eyes. Her dress is black, the chair and the landscape background are only dimly seen. The atmosphere, however, is not melancholy but intense, as if great suffering had not been able to crush an indomitable will. The ebullience of Courbet's own personality seems to have subsided when he faced this mysterious, brooding figure.

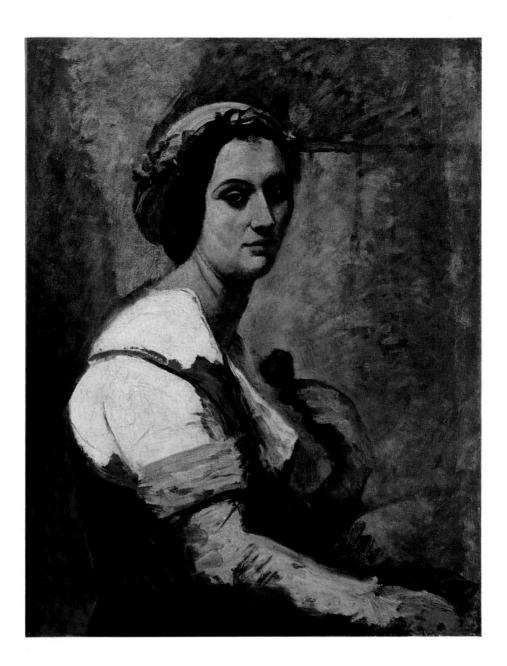

JEAN BAPTISTE CAMILLE COROT

1796–1875

Sibylle

Oil on canvas, 33¹/₄ × 25¹/₂ in.
The H. O. Havemeyer Collection
Bequest of Mrs. H. O. Havemeyer, 29.100.565

In the latter part of his life Corot painted an enormous number of misty, greenish-gray landscapes, often including vaporous nymphs, that sold well. For his own pleasure, however, he continued to make figure studies; these have all the careful observation and classical firmness, combined with poetic feeling and his own characteristic tenderness, that make his earlier works more admired today. This picture was painted about 1870; the title, given to it by an early owner, is probably the name of the model, for there is nothing to indicate that she is a Greek or Roman sibyl.

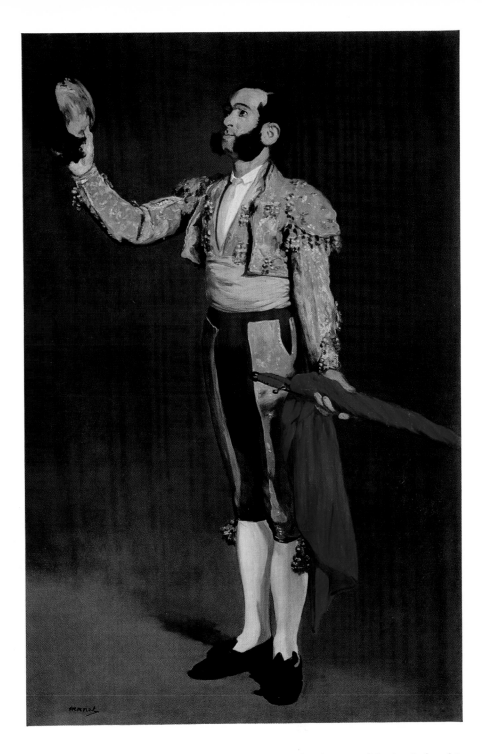

EDOUARD MANET

1832–1883

A Torero Saluting

Oil on canvas, 67³/₈ × 44¹/₂ in.
Signed (lower left): Manet
The H. O. Havemeyer Collection
Bequest of Mrs. H O. Havemeyer, 29.100.52

Manet painted this in 1866, the year after he visited Spain. Before his trip he had produced a number of Spanish subjects showing the influence of the many Spanish pictures he had been able to see in Paris, but this is one of the very few done after his return. The matador is asking the president of the fight to grant permission to kill the bull; his sword is hidden in the folds of the *muleta*. The strong colors and dashing brushwork, the impression of almost brutal force, are reflections of Manet's study of Velázquez and Goya. The picture was obviously painted in the cold glare of a north-lit studio; there is no suggestion of the blinding sun of the bullring.

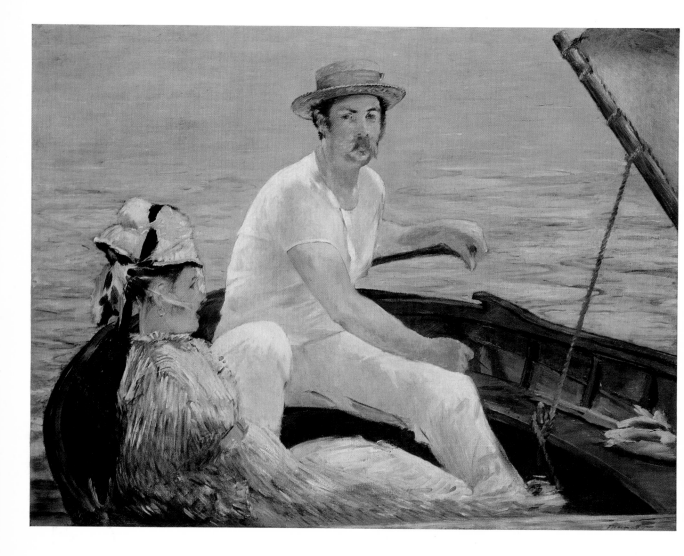

MANET

Boating

Oil on canvas, 38¼ × 51¼ in.
Signed (lower right): Manet
The H. O. Havemeyer Collection
Bequest of Mrs. H. O. Havemeyer, 29.100.115

In the summer of 1874 Manet was at Argenteuil, a resort on the Seine near Paris, where Renoir and Monet were also staying. The latter urged him to paint out-of-doors, and for a brief period Manet did so. In this picture he has adopted the aesthetic approach of the impressionists, for whom, it has been said, "the intensely vivid recreation of any place or thing as it appeared at a particular moment was reason enough for painting a picture." The most finished part is the man's head, lit by reflections from the water, especially noticeable on the underside of his hat. Manet showed the picture at the 1879 Salon, where it was bought, the only one of his works ever sold at these exhibitions.

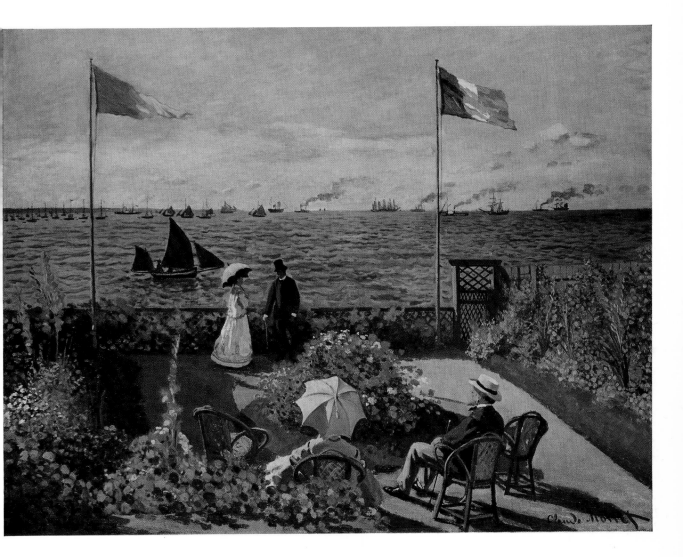

CLAUDE MONET

1840–1926

Terrace at Sainte-Adresse

Oil on canvas, 38⅝ × 51⅛ in.
Purchased with special contributions and
purchase funds given or bequeathed by
friends of the Museum, 67.241

In the early fall of 1866 and again during the following summer Monet stayed with members of his family at Le Havre and at the nearby resort town of Sainte-Adresse, on the English Channel. It was there that he painted this picture. Soon after the Metropolitan acquired it one of the curators wrote that it showed "a garden by the sea, full of bright flowers, radiant in strong sunshine that casts an intricate pattern of shadow, and freshened by a sea breeze that ripples the surface of the water, chases wisps of cloud across the sky, drives before it the gray smoke from little vessels on the far horizon, and whips two banners straight out from their flagpoles with an almost audible snap."

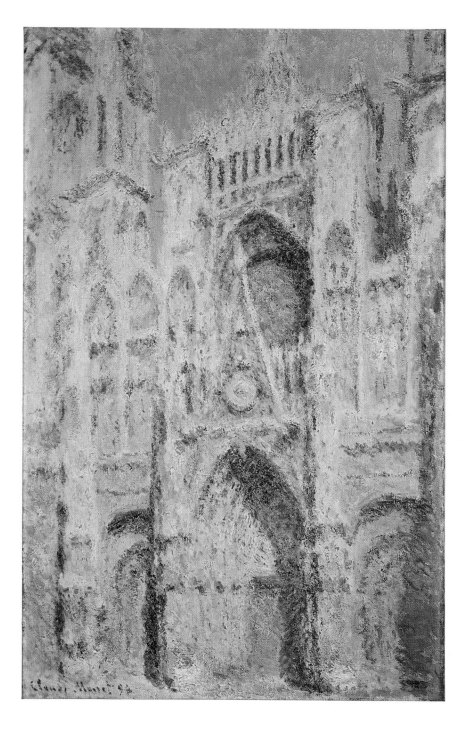

MONET

Rouen Cathedral

Oil on canvas, 39¼ × 25⅞ in.
Signed and dated (lower left): Claude Monet 94
The Theodore M. Davis Collection
Bequest of Theodore M. Davis, 30.95.250

Monet was the most dedicated of the impressionists and the only one who made a system of his method of seeing and reproducing the world. He went to Rouen in February, 1892, and stayed until April, painting in a room on the second floor of a house opposite the cathedral. He had several canvases on which he worked at different times of day or in different weather conditions; this must be a noon-in-sunshine example. Monet returned to Rouen in 1893 at the same season, then spent a year at home reworking the paintings from memory. Outlines have disappeared from these pictures, but when this one is seen from a distance, the massive west front of the cathedral looms in the blinding light like a Gothic vision.

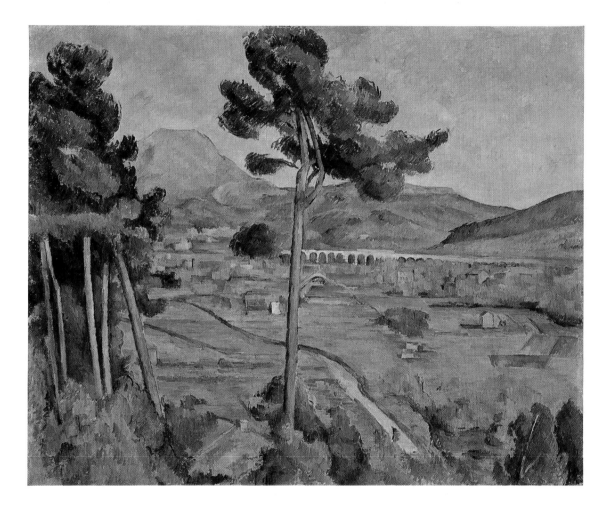

PAUL CEZANNE

1839–1906

Mont Sainte-Victoire

Oil on canvas, 25³/₄ × 32¹/₈ in.
The H. O. Havemeyer Collection
Bequest of Mrs. H. O. Havemeyer, 29.100.64

This is one of four views Cézanne painted of the valley of the river Arc as seen from a little hill above it. In the distance, beyond the railroad viaduct, rises the dramatic outline of Mont Sainte-Victoire, the mountain that Cézanne made one of the best-known landscape silhouettes in the world. This view, painted about 1885–87, is carried to an unusually detailed degree. Every brushstroke is apparent and deliberate: vertical ones in the foreground, horizontal in the valley, curved for the foliage of the trees, square for the houses. Though blues and greens predominate, pinks and yellows occur throughout and help give the impression of the bright light of Provence.

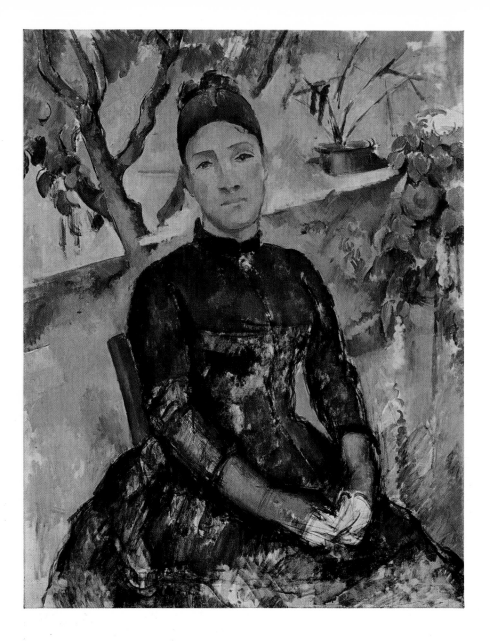

CEZANNE

Madame Cézanne in the Conservatory

Oil on canvas, 36¼ × 28¾ in.
Bequest of Stephen C. Clark, 60.101.2

Hortense Fiquet was a professional model whom Cézanne met in Paris. They had a son in 1872 and were married in 1886, though she continued to live in Paris and he at Aix-en-Provence. She did, however, visit him there and was one of the few people willing to endure the long hours of posing that he required of his sitters. This portrait was made at Aix about 1880. The head and bosom have the sculptural forms that Cézanne strove to attain. Hortense's expression reveals little but the resigned, monumental patience she undoubtedly possessed.

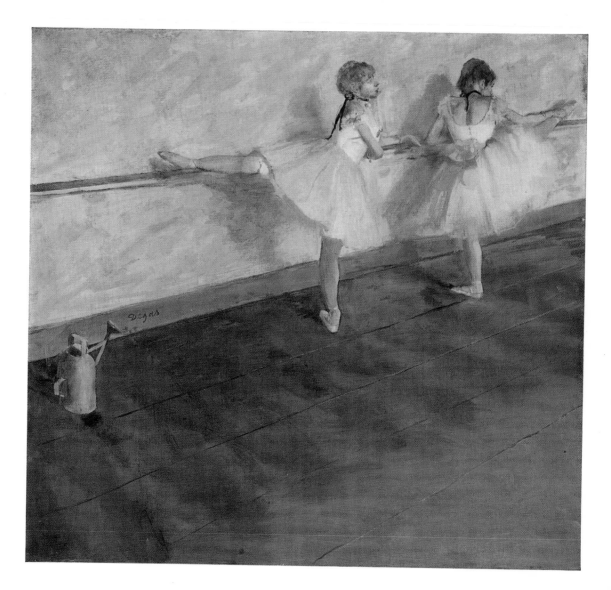

HILAIRE GERMAIN EDGAR DEGAS

1834–1917

Dancers Practicing at the Bar

Oil freely mixed with turpentine, on canvas,
29³/₄×32 in.
Signed (left center, foot of wall): Degas
The H. O. Havemeyer Collection
Bequest of Mrs. H. O. Havemeyer, 29. 100.34

Degas painted this picture with unusually thinned colors, giving it a pastel-like appearance. To avoid deadening its airy lightness, it was never varnished; consequently it has always been kept under glass. It was a present from Degas to a friend, in recompense for a pastel that the painter had ruined in an attempt to improve it. Later, Degas regretted having included the watering can, used in dance studios to lay the dust, but the owner refused him permission to obliterate it; he is said even to have chained the picture to his wall. The daring composition and peculiar color scheme, with a notable absence of blue, make this one of the strangest and most fascinating of Degas's many paintings of ballet dancers.

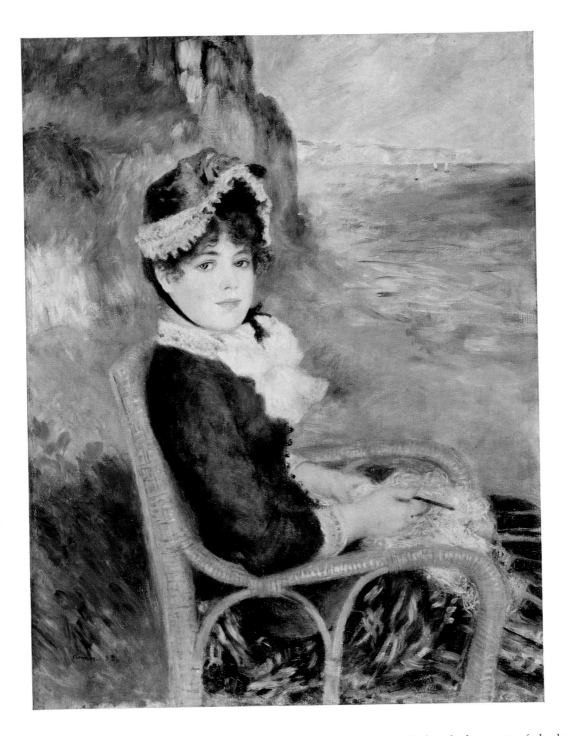

PIERRE AUGUSTE RENOIR

1841–1919

By the Seashore

Oil on canvas, 36¼ × 28½ in.
Signed and dated (lower left): Renoir.83
The H. O. Havemeyer Collection
Bequest of Mrs. H. O. Havemeyer, 29.100.125

Renoir became dissatisfied with the tenets of absolute impressionism in the mid-1880s and began to paint in what he later called his "sour" or "dry" manner—epithets difficult to apply to any picture made by him at any time. What he meant was more careful composition, a greater precision in drawing, and paint that, though still rich in color, is less lush in texture. The new manner is evident here in the porcelain smoothness of the girl's face, painted almost without shadows. The rainbow of quick strokes in the background on the left, however, shows that he had not yet completely abandoned the impressionist method. The scene may be on the Channel Island of Guernsey, where Renoir stayed in September, 1883.

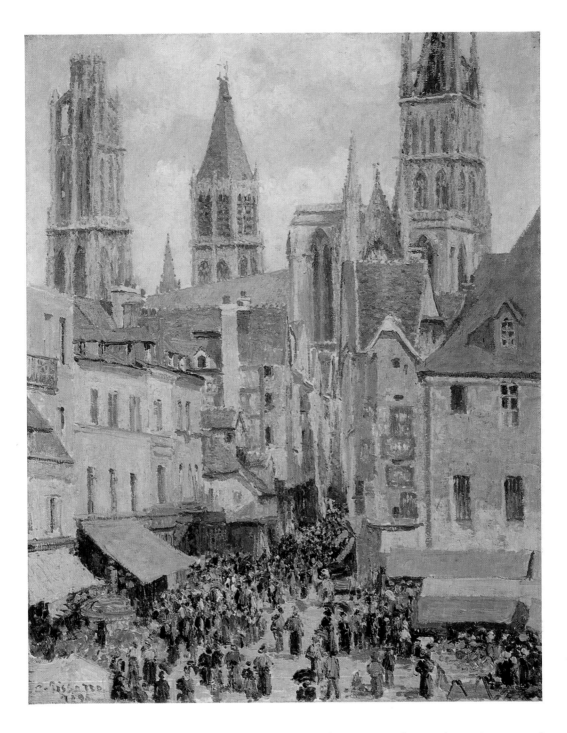

CAMILLE PISSARRO

1830–1903

The Old Market at Rouen
and the Rue de l'Epicerie

Oil on canvas, 32 × 25⅝ in.
Signed and dated (lower left): C. Pissarro 1898
Mr. and Mrs. Richard J. Bernhard Gift, 60.5

Pissarro was a Frenchman of Portuguese descent, hence his unusual surname. He visited Rouen in 1898 and made three pictures of this view—a neighborhood that was largely destroyed in World War II. It is market day; the gay canopies over the stalls gave Pissarro an opportunity to use broad, simple areas of bright color, and the thronging crowd provided a dark, firm base for the painting. Few of the people are seen as individuals. Further away, especially in the mingled tones of the roofs, the handling is more impressionistic. The cathedral towers dominate the sky, but the realistic presentation of the building here differs greatly from the unearthly spectacle of the mighty church shown by Monet.

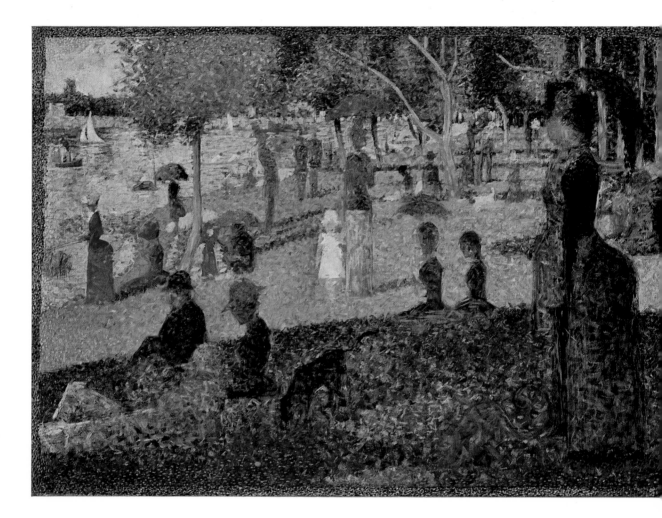

GEORGES SEURAT

1859–1891

*A Sunday Afternoon
at the Grande Jatte*

Oil on canvas, 27³/₄ × 41 in.
Bequest of Samuel A. Lewisohn, 51.112.6

The Grande Jatte is an island in the Seine on the outskirts of Paris. Seurat's painting of this pleasure ground in The Art Institute of Chicago, like his five other large pictures, was preceded by many drawings and oil sketches; in these he worked out with the utmost care the placing and appearance of every figure. The Metropolitan's picture, which has been called the definitive sketch, is one of the largest and latest studies for the final painting of 1886. The colors are more intense than in the Chicago picture and there is less emphasis on the outlines and volumes of the figures; they are like phantoms instead of solid statues.

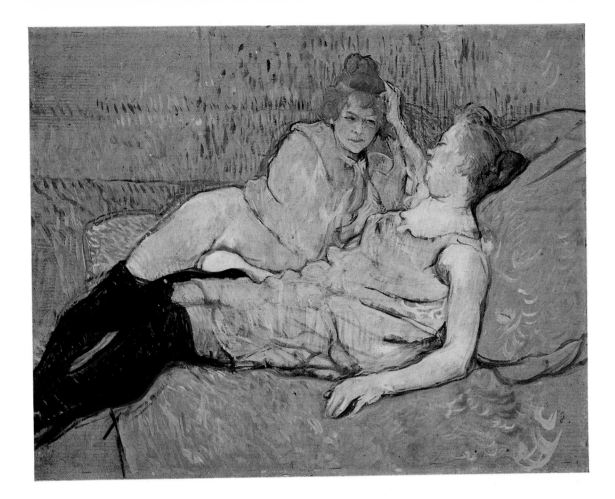

HENRI DE TOULOUSE-LAUTREC

1864–1901

The Sofa

Oil on cardboard, 24³/₄ × 31⁷/₈ in.
Stamped with monogram (lower left): HTL
Rogers Fund, 51.33.2

Toulouse-Lautrec sometimes actually lived in Parisian brothels during the years 1892–96 and so saw the inmates when the smiles were off their faces. This rapid sketch, hardly more than a colored drawing made with the brush, could have been done from life. The cardboard ground has been left uncovered in many areas; the colors are delicate, exquisite, and subtle. Both women appear in other works by the artist; he looks at them here not as caricatures, but with a cold indifference that is close to cruelty. They are relaxed, exhausted, bored, and without hope.

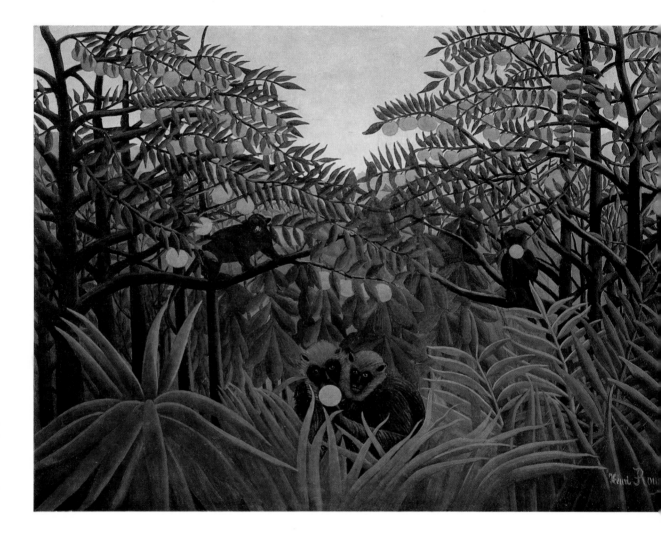

HENRI ("LE DOUANIER") ROUSSEAU

1844–1910

Tropics

Oil on canvas, 43³/₄ × 64 in.
Signed (lower right): Henri Rousseau
Bequest of Adelaide Milton de Groot
 (1876–1967), 67.187.98

Rousseau probably never saw the tropics. He did, however, sketch in the Paris zoo and botanic garden, and he copied old masters in the Louvre. Though he was an official at a Paris tollgate for twenty-two years (hence his nickname, "the Customs Inspector"), he considered himself a serious artist. He was, in fact, self-taught, but by no means an amateur, a "Sunday painter." From 1893 until his death he did nothing but paint. The pair of sad-eyed monkeys here are based on observation from life, and the composition, with the break in the trees focusing attention on the two beasts below, is the work of a master. The general impression is strange, but the work is not naïve; it is intense, tragic, and as powerful as a sledge hammer.

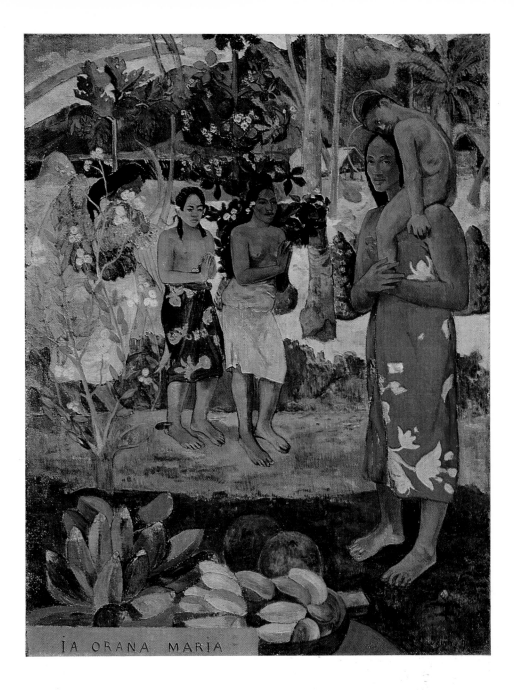

IA ORANA MARIA

PAUL GAUGUIN

1848–1903

Ia Orana Maria (I Hail Thee, Mary)

Oil on canvas, 44³/₄ × 34¹/₂ in.
Signed and dated (lower right): P. Gauguin '91;
 inscribed (lower left): IA ORANA MARIA
Bequest of Samuel A. Lewisohn, 51.112.2

In 1883 Gauguin abandoned his family and his business to devote himself to art. He arrived in Tahiti in 1891, and this is one of the first pictures he made there. It shows not only the effect that tropical forms and colors had on him, but also the influence of exotic works of art; the two worshipers are derived from a Javanese bas-relief of which he is known to have possessed a photograph. The words of the Polynesian inscription, the halos of the woman and child, and the angel at the left belong to the traditions of Christianity, though the picture is far from a conventional rendering of the Annunciation. The land and its people have become to the artist as holy as the divine personages.

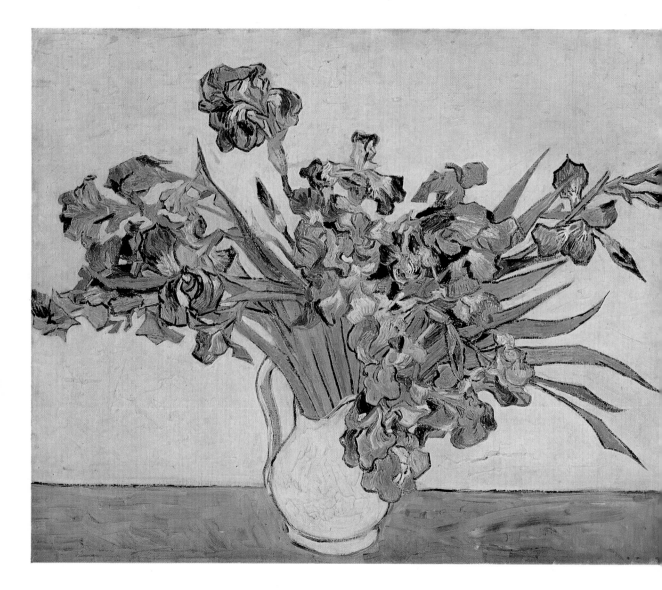

VINCENT VAN GOGH

1853–1890

Irises

Oil on canvas, 29 × 36¼ in.
Gift of Adele R. Levy, 58.187

Thanks to van Gogh's letters, we can follow the state of his tormented mind through most of his short working life. The latest period when he wrote of satisfaction and happiness was in May, 1890, near the end of his stay at the hospital of Saint-Rémy in Provence. While confined there because of his encroaching insanity, he made 150 paintings and hundreds of drawings. Among the May paintings were two of irises that have been called the last clear and joyful expression of his art and spirit. Van Gogh could be visually and mentally stimulated by anything—old books, furniture, trees, people—and whatever he put on canvas he made exciting. No one else could have seen such demonic energy in the noble sculptural forms of these flowers.

ODILON REDON

1840–1916

Etruscan Vase with Flowers

Tempera on canvas, 32 × 23¼ in.
Maria DeWitt Jesup Fund; acquired from The
 Museum of Modern Art, Lizzie P. Bliss
 Collection, 53.140.5

Redon said that he wished "to place the logic of the visible at the service of the invisible." This ambition accounts for the unearthliness that can be felt in most of his works, even in such a conventional subject as a vase of flowers. Not all the flowers here are real ones, and the color scheme is not that of everyday blooms. Painted about 1910, this picture came to the United States shortly afterward, and it may have been in the New York Armory exhibition of 1913, which introduced Americans to modern art, though it is not identifiable in the catalogue. The vase is presumably an ancient Greek one, formerly thought to be Etruscan, or perhaps an imitation.

PABLO PICASSO

b. 1881

Gertrude Stein (1874–1946)

Oil on canvas, 39³/₈ × 32 in.
Bequest of Gertrude Stein, 47.106

Miss Stein sat for this portrait some eighty or ninety times in the winter of 1905. Picasso then wiped out the head and left Paris. "The day he returned from Spain," the sitter wrote in *The Autobiography of Alice B. Toklas*, "Picasso sat down and out of his head painted the head in without having seen Gertrude Stein again. And when she saw it he and she were content. Everybody except Miss Toklas thought she did not look like it; Picasso said, 'She will.'" This is the only picture from her fabulous collection that Miss Stein bequeathed to the Metropolitan Museum, and just as for her it was the only reproduction "which is always I, for me," so now it is Gertrude Stein for all the world for evermore.

BRITISH SCHOOL

WILLIAM HOGARTH

1697–1764

The Wedding of Stephen Beckingham and Mary Cox

Oil on canvas, 50¹/₂ × 40¹/₂ in.
Inscribed, dated, and signed (lower left):
 Nuptiae: Stp: Beckingham: Arr [Nuptials,
 Stephen Beckingham, gentleman]/June:
 9th: 1729: Wm: Hogarth: Pinxt:
Marquand Fund, 36.111

The scene is set, with some modifications, in the east end of the famous London church of Saint Martin's-in-the-Fields, though the Beckingham-Cox marriage was actually solemnized in a smaller London church. This is one of Hogarth's earliest known works, and the tall, slim figures are extremely decorous, with little hint of the ironic style for which he was later to be celebrated. The two figures on a balcony in the upper right corner, however, are typical of him. The cupids emptying a horn of plenty above the happy pair were painted on top of a chandelier, apparently in an effort to supply some symbolic richness to the rather factual architectural setting and to emphasize the compositional center.

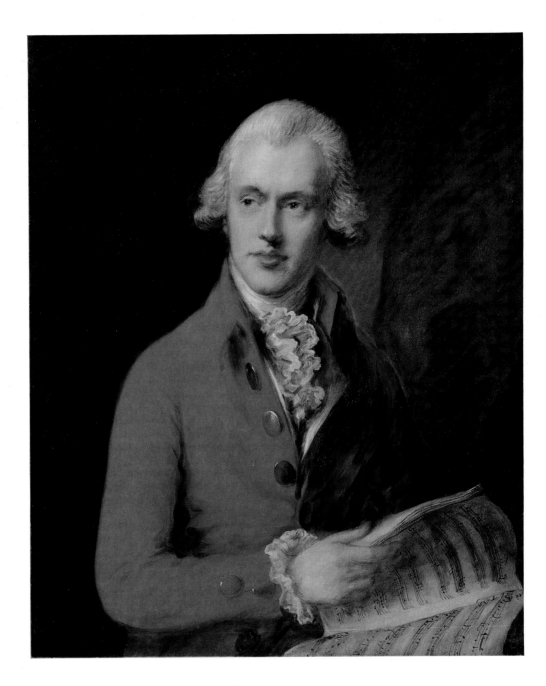

THOMAS GAINSBOROUGH

1727–1788

Charles Rousseau Burney (1747–1819)

Oil on canvas, 30¹/₄ × 25¹/₈ in.
Bequest of Mary Stillman Harkness, 50.145.16

The sitter is not the famous musical historian Charles Burney (who would have been in his fifties when this portrait was painted in the late 1770s), but rather his nephew and son-in-law, also a musician, as the sheet of music he holds indicates. Both Burneys would have been congenial subjects for Gainsborough, whose passion for music was one of his most winning traits; when he was "sick of portraits," he wrote in a letter, "my comfort is I have five viols da gamba." Gainsborough's feelings about his sitters can usually be deduced from their portraits. When they bored him, he produced a dull picture. Only when he liked a person, as he clearly did this sensitive gentleman, did he do good work.

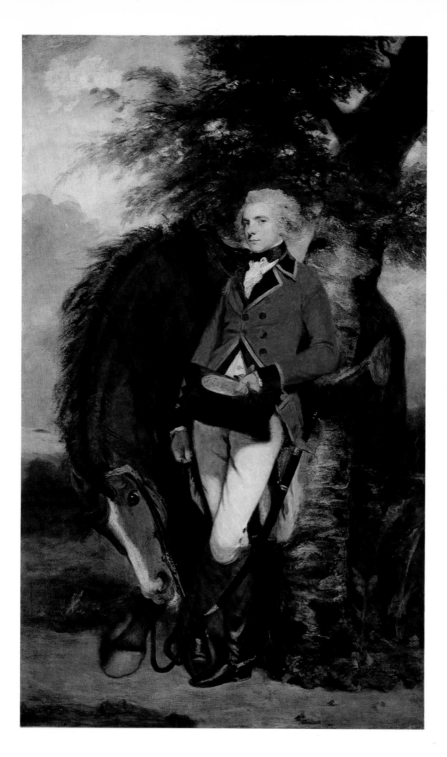

JOSHUA REYNOLDS

1723–1792

Colonel George K. H. Coussmaker,
Grenadier Guards (1759–1801)

Oil on canvas, 93³/₄ × 57¹/₄ in.
Bequest of William K. Vanderbilt, 20.155.3

In the list of Reynolds's sitters for 1782 "Mr. Coussmaker" appears in February and "Mr. Coussmaker's horse" in March; the fiery steed was perhaps the more interesting of the pair to the artist. Reynolds was admired for the variety of poses that he contrived for his clients, and he has certainly found an original one for the youthful officer. In spite of his colorful regimentals, Coussmaker looks as if he might have depended a good deal on his top sergeant. The somewhat vacuous face, however, is scarcely noticeable as its owner poses nonchalantly between the great curves of the tree and the restive but obedient animal.

HENRY RAEBURN

1756–1823

The Drummond Children (George,
on pony, 1802–1851, Margaret, and
their foster brother)

Oil on canvas, 94¼ × 60¼ in.
Bequest of Mary Stillman Harkness, 50.145.31

The Scottish family of Drummond can trace its ancestry to the eleventh century and count three queens of Scotland in the line. Raeburn painted these children about 1808; his portrait of their father is also in the Metropolitan. The startlingly dramatic effects of light and shade, with nearly black shadows, the simplification of the planes in the costumes, the bold, squared-off brushwork, and the color scheme, with its russets and dull greens, are all typical of Raeburn's forthright style. This style evidently pleased his clients, for he was highly successful as a portraitist in Scotland.

JOHN CONSTABLE

1776–1837

*Salisbury Cathedral
from the Bishop's Garden*

Oil on canvas, 34⅝×44 in.
Bequest of Mary Stillman Harkness, 50.145.8

Most English Gothic cathedrals do not rise above a jumble of house-tops like their counterparts on the Continent, but are surrounded by stretches of greensward with scattered trees. Salisbury has one of the most beautiful of these settings. Constable had patrons and close friends there with whom he stayed frequently from 1811 to 1829. He painted a version of exactly this view of the cathedral (now in the Victoria and Albert Museum) as a commission for the bishop in 1823. Of this he wrote: "It was the most difficult subject in landscape I ever had upon my easil. I have not flinched at the work, of the windows, buttresses, &c, &c, but I have as usual made my escape in the evanescence of the chiaroscuro."

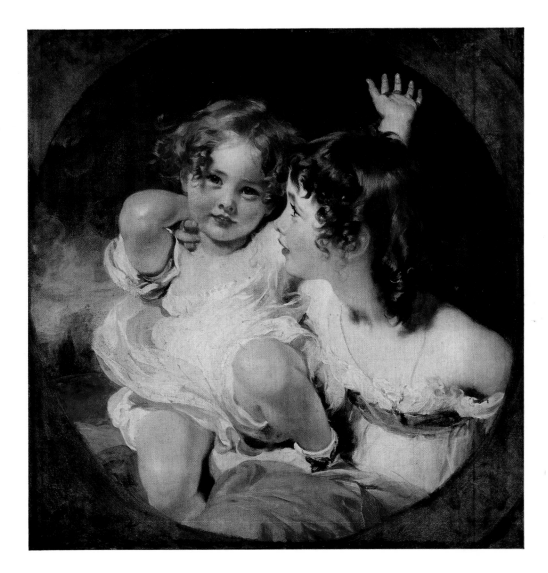

THOMAS LAWRENCE

1769–1830

The Calmady Children

Oil on canvas, 30⁷/₈ × 30¹/₈ in.
Bequest of Collis P. Huntington, 25.110.1

Dark-haired Emily (1818–1906) was five and golden-haired Laura
Anne (1820–1894) three when Lawrence saw them and thought they
were so pretty that he offered to paint them for much less than his
usual fee. Charles Biggs Calmady's older daughter, however, seems
little more than a dark foil to Laura Anne, who was clearly the main
attraction; her skin is more glistening, her cheeks are rosier, and she
alone has Lawrence's typical brilliant eyes, with a spot of pure white
paint in each. "This is my best picture," was Lawrence's judgment.
"I have no hesitation in saying so—my best picture of the kind—one
of the few I should wish hereafter to be known by." His wish has
been granted.

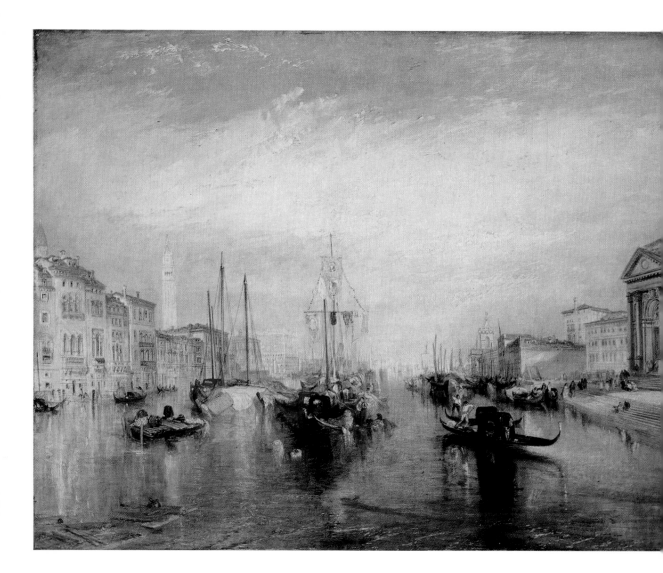

JOSEPH MALLORD WILLIAM TURNER

1775–1851

Grand Canal, Venice

Oil on canvas, 36 × 48⅛ in.
Bequest of Cornelius Vanderbilt, 99.31

We are looking along the canal toward the sea, with the campanile of Saint Mark's and the Doge's Palace on the left, the Dogana and Santa Maria della Salute on the right. Turner, however, was not concerned with merely reproducing the city as visitors might like to remember it. By 1835, when this picture was painted, he had carried his experiments with color much further than in the topographical renderings of his youth. He was more interested in the reflections on the water than in the buildings, boats, and people that are reflected. Canaletto and Guardi used the bright sunshine of Venice to define architectural forms; Turner diffuses the light, minimizes the shadows, and suggests the hazy, colorful atmosphere that sometimes bathes the city.

AMERICAN SCHOOL

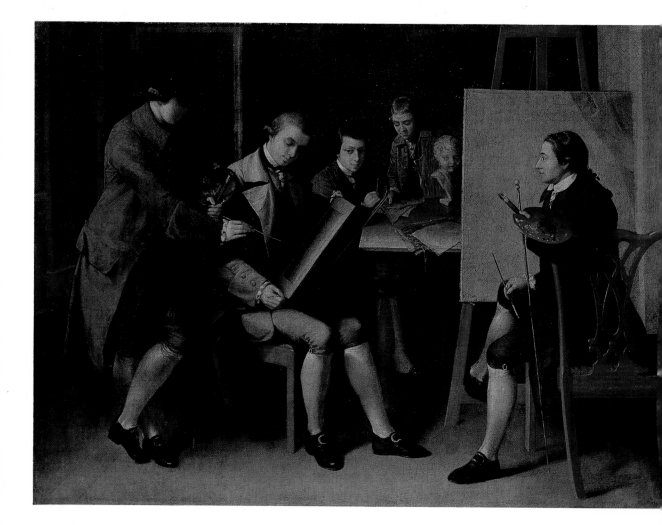

MATTHEW PRATT

1734–1805

The American School, 1765

Oil on canvas, 36 × 50¹/₂ in.
Gift of Samuel P. Avery, 97.29.3

From the mid-1760s to the early 1800s Benjamin West's London studio served in part as a center for visiting American painters eager for closer contact with the mainstream of European art. The hospitality and guidance West offered his countrymen is charmingly documented in this conversation piece that Matthew Pratt painted during his residence in West's "very elegant house." Most of the figures are no longer identifiable, but West is obviously the instructor standing at the left, and Pratt is thought to be the pupil seated next to him. Despite some overemphatic modeling, the figures relate to one another in a pleasantly informal yet dignified composition—an achievement made possible by Pratt's adherence to West's clearly formulated principles of neoclassic style.

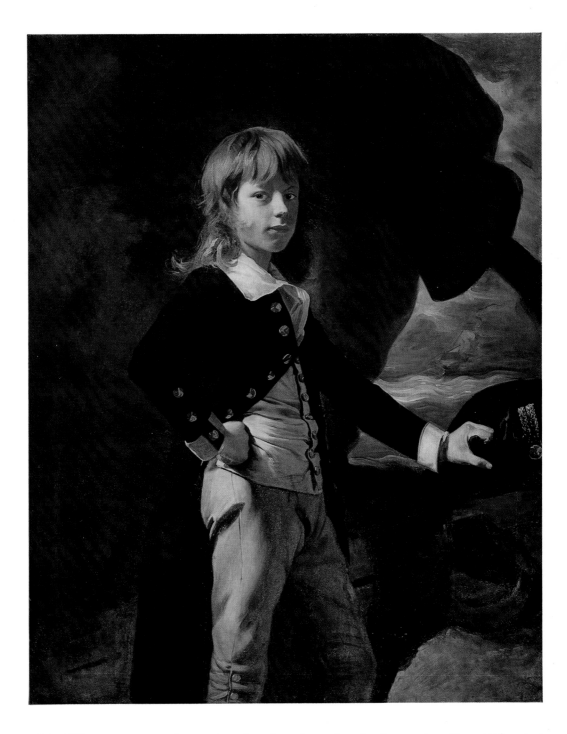

JOHN SINGLETON COPLEY

1738–1815

Midshipman Augustus Brine, 1782

Oil on canvas, 50×40 in.
Bequest of Richard D. Brixey, 43.86.4

In a setting of overhanging rock and a giant anchor silhouetted against a stormy sea, Augustus Brine looks out on the world with the assurance of a seasoned officer in His Majesty's navy. Yet when he posed, Brine was just twelve years old and but recently enlisted as a midshipman on a vessel commanded by his father, Admiral James Brine. The flamboyant composition and hint of bravura in the brushwork show a radical change from the robust simplicity of the artist's "liny" American style—a change that had taken place during his eight years in London. Though this increase in virtuosity and elegance was often accompanied by a loss in expressive power, Copley's likeness of young Brine holds its own with the outstanding portraits of his American period.

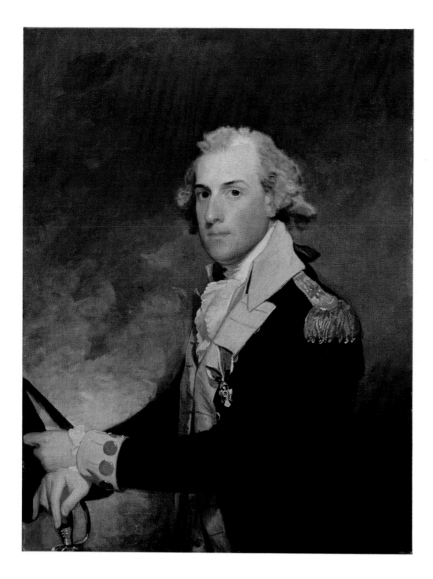

GILBERT STUART

1755–1828

Matthew Clarkson, about 1794

Oil on canvas, 36¹/₂ × 28¹/₄ in.
Bequest of Helen Shelton Clarkson, 38.61

Clarkson (1758–1825) was one of many prominent New Yorkers who posed for Stuart after the artist's return from London and Dublin, where he had developed his own laconic version of the somewhat florid Georgian style. Note, for instance, Stuart's incisive rendering of the eyes and the crisp accents on the uniform. A background tonal gradation moving upward from light to dark throws the head into sharp relief, at the same time suggesting the smoke of battle and Clarkson's earlier role in the Revolution. Uniformed here as a brigadier general in the New York state militia and wearing the order of the Cincinnati, he was to serve also as a state senator, regent of the state university, and president of the Bank of New York.

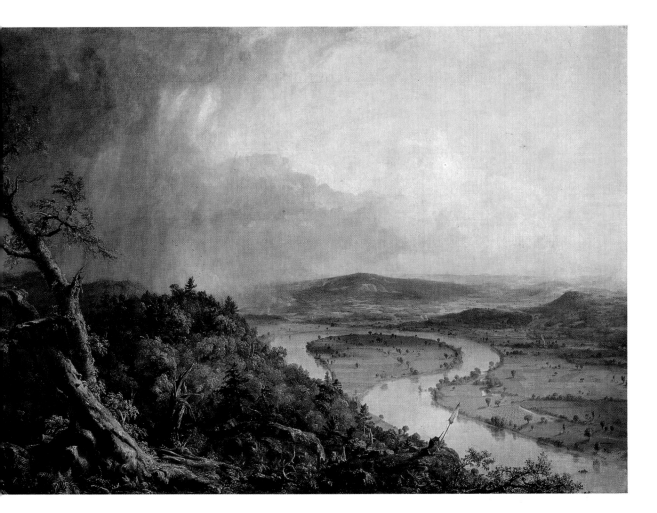

THOMAS COLE

1801–1848

The Oxbow (The Connecticut River
near Northampton)

Oil on canvas, 51¹/₂ × 76 in.
Signed and dated (lower left): T. Cole 1836
Gift of Mrs. Russell Sage, 08.228

"I would not live where tempests never come, for they bring beauty in their train." So wrote Cole in his diary the year before he painted this magnificent panorama of the Connecticut River valley. It is thus not surprising to find that he selected the moment immediately following a cloudburst, when all nature seems suddenly freshened, and foliage, still wet, glitters in the crisp new light. If the elemental drama of this landscape is what first impresses the viewer, closer scrutiny reveals a marvelous wealth of detail—especially in the rocks and vegetation along the foreground promontory. Perched on a rock to the right are a folding chair, umbrella, and portfolio, and, just beyond, the artist himself looks up from his sketch of the valley below.

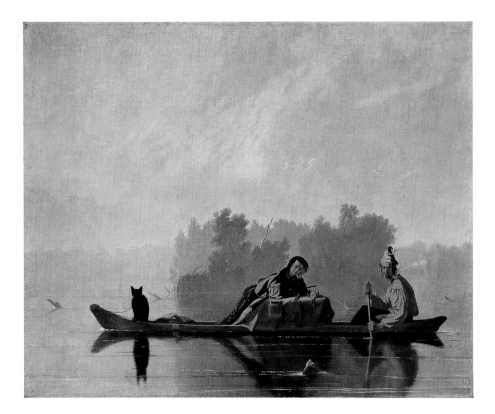

GEORGE CALEB BINGHAM

1808–1879

Fur Traders Descending the Missouri,
1845

Oil on canvas, 29 × 36¹/₂ in.
Morris K. Jesup Fund, 23.61

This genre work records what may still have been a familiar sight during Bingham's travels in the early 1840s. For almost a century French traders had penetrated the great river wilderness on foot, bartering for furs with the Indians and then transporting their cargoes downstream in dugouts like this one. But Bingham has here raised anecdote to the level of poetic drama by setting up a tension between the suspicious stare of the old trader, the unconcerned reverie of his sprawling offspring, and the compact, enigmatic silhouette of their pet fox. Parallel planes receding into deep space suggest the artist's familiarity with engravings from classical European paintings, yet the strict formality is softened by magical effects of an exquisitely luminous atmosphere.

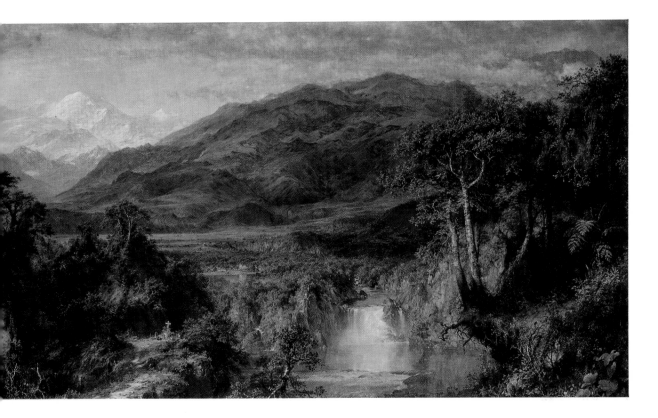

FREDERIC EDWIN CHURCH

1826–1900

The Heart of the Andes

Oil on canvas, 66¹/₂ × 119¹/₄ in.
Dated and signed (lower left):
 1859/F. E. CHURCH
Bequest of Mrs. David Dows, 09.95

In the spring of 1859, when this panorama of the Ecuadorian mountain wilderness by Thomas Cole's brilliant young disciple was new, more than twelve thousand visitors paid twenty-five cents apiece to view it. When first shown in the artist's New York studio, it was flanked with specimens of tropical foliage and illuminated by gas jets, creating an illusion of an actual landscape viewed through a window. Once the visitor had appreciated the grandeur of the whole, he was invited to peer bit by bit at its marvelously rendered details through a tube supplied by the artist. No other painting in the history of American art has received such ecstatic praise from its contemporary critics and public alike.

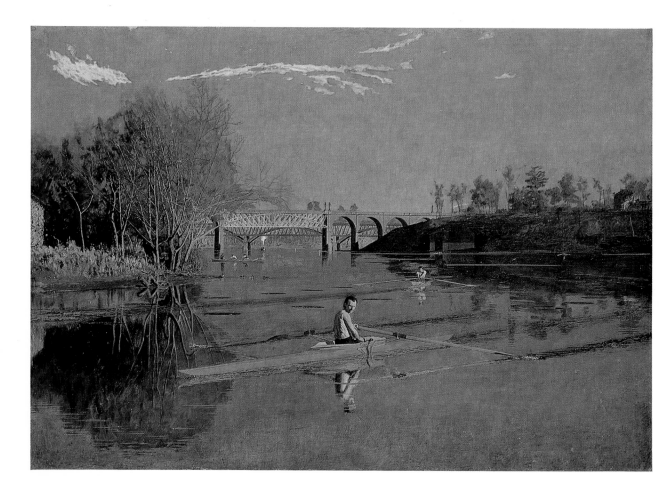

THOMAS EAKINS

1844–1916

Max Schmitt in a Single Scull

Oil on canvas, 32½ × 46¼ in.
Signed and dated (on shell, middle distance):
 EAKINS/1871
Alfred N. Punnett Endowment Fund and Gift
 of George D. Pratt, 34.92

In this haunting picture the artist's passion for sports is suffused with a lyrical response to subtle qualities of light and to the rhythmic placement of forms in deep space. In a serene and spacious setting, provided by the Schuylkill River flowing through Philadelphia's Fairmount Park, Eakins's friend Max Schmitt turns toward us as if awaiting the click of our camera, while, just beyond, the artist himself pulls away in a shell marked with his name. Accents in the distance are created by other oarsmen, a train approaching the near bridge, and a boat puffing smoke. Most of the details are crystal clear, yet here and there passages are more freely painted, such as the stone house and leafy shore at the left.

JOHN SINGER SARGENT

1856–1925

Portrait of Madame X

Oil on canvas, 82¹/₈ × 43¹/₄ in.
Signed (lower right): John S. Sargent 1884
Arthur Hoppock Hearn Fund, 16.53

The low cut of the lady's gown in this striking portrait caused such a scandal at the Paris Salon of 1884 that Sargent withdrew the painting and shortly afterward took refuge in London, where he settled permanently a year later. The subject was Madame Gautreau, a famous Parisian beauty of the eighties, but anticipating controversy, Sargent asked that the picture be called by its present title. A large oil sketch for the portrait was given to the Tate Gallery, London, by Lord Duveen. In 1915, a few months before the Metropolitan acquired the final canvas, Sargent wrote the Museum's director, Edward Robinson, that he considered *Madame X* the best painting he had ever done.

MARY CASSATT

1845–1926

The Cup of Tea, about 1879

Oil on canvas, 36³/₈ × 25³/₄ in.
Signed (lower left): Mary Cassatt
Anonymous gift, 22.16.17

"I will not admit that a woman can draw so well," said Edgar Degas as he examined a painting by his young American protégée Mary Cassatt. In 1877, when the two artists first became acquainted, Degas persuaded Miss Cassatt to stop submitting her pictures to the ultra-conservative Salons and show henceforth with his own group, the impressionists. *The Cup of Tea*—actually a portrait of the artist's sister Lydia—was in the impressionist exhibitions of 1879 and 1881. In the latter it received high praise from the liberal critic J. K. Huysmans, who wrote that this talented American had achieved something that none of the French painters could express: "the happy contentment, the quiet friendliness of an interior."

WINSLOW HOMER

1836–1910

The Gulf Stream

Oil on canvas, 28¹/₈ × 49¹/₈ in.
Signed and dated (lower left): HOMER/1899
Catharine Lorillard Wolfe Collection, 06.1234

Though *The Gulf Stream* dates from 1899, its emphasis on storytelling and the perils of men at sea suggests Homer's earlier style of the 1880s. Moreover, the motif of a dismasted sloop in a shark-filled sea comes directly from a watercolor the artist had painted in 1885 during a visit to Nassau. Yet the powerfully rhythmic brushstrokes and the broad sweep of the composition proclaim *The Gulf Stream* a masterpiece of Homer's later style, when he finally combined the freedom of his watercolors with the solidity of his oils. Though highly praised by critics, the painting remained unsold until 1906, when the Metropolitan purchased it on the urging of the exhibition jury of the National Academy of Design.

AMERICAN SCHOOL, TWENTIETH CENTURY

MARSDEN HARTLEY

1877–1943

Portrait of a German Officer, 1914

Oil on canvas, 68¼ × 41⅜ in.
Alfred Stieglitz Collection, 49.70.42

Dedicated to a friend whose initials appear in the lower left corner, this "portrait" is one of several paintings with military symbols completed during 1914–1915 while the artist was living in Berlin. His abstract arrangement of these symbols shows the influence of ideas then current in German painting, yet the emblems themselves are realistic rather than abstract, and presented without distortion as complete entities. Like the crescendo of a military band, they expand in scale as the composition develops upward from the spur and epaulets to sweeping circular shapes that culminate in the Iron Cross. Asked for the meaning of these forms, Hartley replied that there is "no hidden symbolism whatsoever in them. . . . They are merely consultations of the eye . . . my notion of the purely pictorial."

JOSEPH STELLA

1877–1946

Coney Island, about 1915

Oil on canvas, d. 41³/₄ in.
Signed (lower right): Jos. Stella
George A. Hearn Fund, 63.69

The prismatic shimmer of this decorative picture recalls Stella's ear-
lier involvement in the Italian futurist movement during his three
years of study abroad. After returning to America in 1912, he was fas-
cinated by the brilliance of New York City. "Steel and electricity,"
he wrote later, "had created a new world." In *Coney Island* fluttering
shapes of blue, green, and violet suggest a swarm of figures—those on
the left surging toward the spectator, others, on the right, turning in-
ward. Near the center the swirling action subsides, yielding to a row
of slender trees silhouetted against a gently receding landscape. Once
there, our attention is drawn to the figure of the Madonna—a revered
image out of the past transplanted here into a dynamic setting of
speed and fragmentation.

ARSHILE GORKY

1904–1948

Water of the Flowery Mill, 1944

Oil on canvas, 42¹/₂ × 48³/₄ in.
George A. Hearn Fund, 56.205.1

In one of his comments about this painting Gorky recalled having seen, "down the road, by the stream," an abandoned mill covered with vines, flowers, and birds. Gorky's titles, however, tend to be allusive rather than descriptive. Thus "flowery mill" is not only a pun but a possible metaphor denoting the riotous milling about of colors and forms in the painting itself. While omnivorous organisms in the foreground devour one another, hybrid flowerlike configurations shoot upward, as if suddenly freed of decayed husks or other discarded matter. All this frenetic activity takes place within the crowded limits of a voluptuous "garden" cultivated by the artist's fertile imagination.

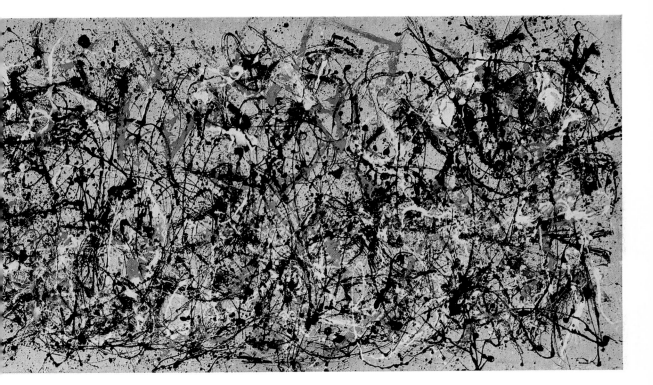

JACKSON POLLOCK

1912–1956

Autumn Rhythm

Oil on canvas, 105 × 207 in.
Signed and dated (lower right):
 Jackson Pollock 50
George A. Hearn Fund, 57.92

Pollock insisted that each of his paintings must have a "life of its own"—free of any reference to nature. In this one no clear distinction exists between foreground and background: near and far seem entangled in a labyrinthine web of furious action. Thin dark lines, swinging wildly in whiplash curves or streaking in sudden cometlike trajectories, are tempered by soft patches of brown repeated rhythmically across the canvas. To create such spontaneous effects, Pollock worked with his canvas unstretched and laid flat. Stepping across the picture surface like the Indian sand painters of his native Southwest, he dripped or threw the pigment from the end of his brush. He painted many of these passages at high speed—but always with exquisite control.

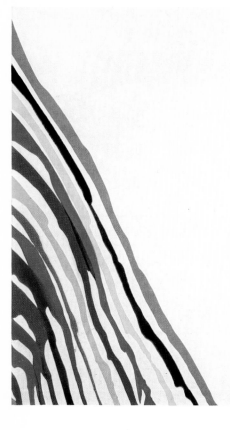

MORRIS LOUIS

1912–1962

Alpha-Pi, 1961

Acrylic on canvas, 102¹/₂ × 177 in.
Arthur Hoppock Hearn Fund, 67.232

During 1961 Louis completed a series of paintings he called "un-furleds," of which *Alpha-Pi* is a fine example. On this giant canvas rivulets of color "unfurl" toward the center, revealing a vast blank space of dazzling light—the kind of instantaneous, all-encompassing space that must be sensed rather than measured by the rules of perspective. Louis used a fluid medium, pouring his colors onto an unsized canvas laid flat. By tilting portions of the canvas, he directed the flow of paint until it had soaked into the fabric to become an integral part of its structure. Because all parts of the canvas are therefore similar in texture, each unstained area functions as a positive form and color rather than merely a "leftover" space.

LIST OF PLATES

178